Photography and Flight

exposures

EXPOSURES is a series of books on photography designed to explore the rich history of the medium from thematic perspectives. Each title presents a striking collection of approximately 80 images and an engaging, accessible text that offers intriguing insights into a specific theme or subject.

Series editors: Mark Haworth-Booth and Peter Hamilton

Also published

Photography and Australia Helen Ennis

Photography and Spirit John Harvey

Photography and Cinema David Campany

Photography and Science Kelley Wilder

Photography and Literature François Brunet

Photography and Egypt Maria Golia

Photography and Flight

Denis Cosgrove and William L. Fox

reaktion books

Published by Reaktion Books Ltd
33 Great Sutton Street
London EC1V 0DX
www.reaktionbooks.co.uk

First published 2010

Printed and bound in China

British Library Cataloguing in Publication Data
Cosgrove, Denis E.
 Photography and flight. – (Exposures)
 1. Aerial photography
 I. Title
 II. Fox, William L., 1949–
 778.3'5

 ISBN 978 1 86189 398 7

Contents

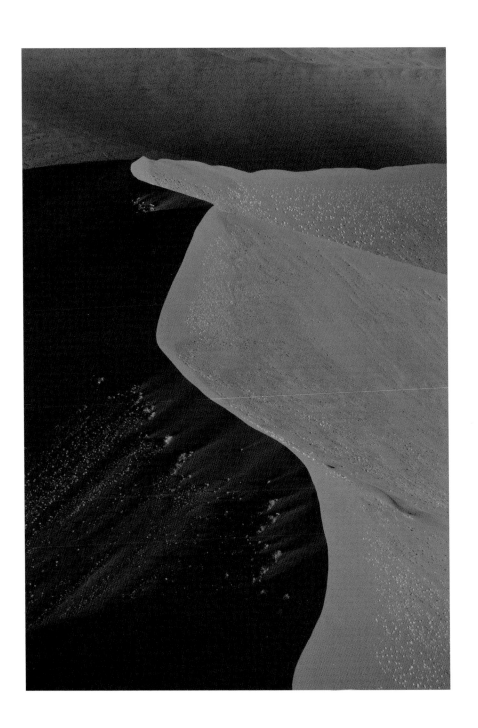

one

The View from Above

On 13 October 1860, the photographer James Wallace (always referred to as J. W.) Black accompanied the balloonist Samuel A. King, and took a photograph from high over the city of Boston, Massachusetts (illus. 1). Framed as an oval cameo resembling the fashionable pendants of contemporary women's neckwear, it shows the streets and city blocks curving away towards the city's North End, the peninsula framed by the Charles River and the Harbor. In later years Wallace took other aerial photographs of Boston, including a dramatic set of panoramic views of the smouldering ruins of its financial district following the fire of 1872. These albumen prints were published in a collection that appealed directly to the picturesque taste for ruins generated by popular landscape paintings and prints such as those produced in the same years by the lithographic printmakers Currier & Ives. The photographs have a map-like quality, but they are not cartographic: there are no words or symbols to elucidate the image; there is no indication of scale or direction; they assume a high oblique perspective over space rather than a vertical view of the ground. Yet they are immediately recognizable to us as cityscapes seen from above. And this instant recognition was as true for mid-nineteenth-century viewers as for ourselves. To be sure, people were fascinated by the novelty of early aerial photographs, and fascination with such images has not dwindled – the global success of Yann Arthus-Bertrand's best-selling *The Earth from the Air: 365 Days* is commercial testament to that fact – but they did not find them difficult to interpret, as might be the case for the graphic forms of statistical representation also being developed in those years. We might ask, therefore, where the familiarity and fascination

1 Sossusvlei desert, Namibia.

come from and how they relate to the much older and related traditions of mapping, which also offer the illusion of seeing the world from above, and with which nineteenth-century viewers of aerial photographs were much more familiar.

God's-Eye View

The aerial photograph shares with the map what we might call the 'God's-Eye' view of the earth and its landscapes. Viewing the world from high above has many ramifications. Physical elevation and the ability to see across great distances of space give a sense of mastery: think of Satan tempting Christ with world dominion from a mountain top in Judaea, or of the consistent connection humans make between elevation, authority and power. The histories of mapping, survey (literally 'overview') and landscape art are closely intertwined with power and control in the world's literate cultures. The term 'bird's-eye perspective' acknowledges the close connection between the God's-Eye view and flight, of which humans are physically incapable but of which they have dreamed throughout history. Photography was invented and perfected during the nineteenth century, a time when balloon flight became increasingly widespread and powered flight was first being attempted. The co-evolution of photography and flight would produce a dominant way of seeing and picturing the modern world of the twentieth and twenty-first centuries. The two histories are thus inextricable, and cannot be separated from questions of spatial cognition and representation that reach back much further than the inventive nineteenth century.

Both photography and human flight are technologies constituted by a set of diverse tools and techniques that were developed for specific purposes. Photography's purpose is at once prosthetic and aesthetic (in the broadest sense of the word): to extend the capacity of the human eye to perceive the world, and to capture and freeze a moment in space and time, documenting and archiving it, and rendering it mobile through the printed or transmitted image. Through mechanical, chemical, optical and digital manipulation, photography may radically alter the world as

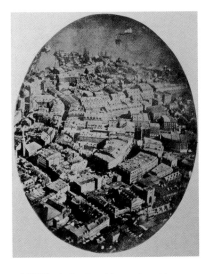

2 J. W. Black, Boston, Massachusetts, 1860.

pictured, determining perspective and framing, bringing small or distant things into our view, enlarging the scope and frame of natural vision, changing or enhancing the colour spectrum and atmosphere of the objects and spaces it represents. It can bring geographically and historically distant places and events into present place and time with astonishing verisimilitude. The purpose of flight, initially by balloon and, since the turn of the last century, by powered aircraft, is to overcome the physiological constraints that keep our upright, mobile, forward-looking bodies tethered to the earth's surface. While long imagined and variously anticipated, the technical achievement of photographic representation and human flight produce powerful phenomenological effects. This is apparent in the fascination of any small child with taking photographs or flying in an aircraft. Photographs made during flight – most often, but not always, looking downward at the Earth – capture and record the powerful experience of the God's-Eye view, allowing us to engage vicariously its complex resonances of omniscience and authority while permitting the pilot and photographer great creative latitude to frame, compose and enhance the terrestrial scene. What aerial photography does best perhaps, and what it shares with the map, is to establish a context for individual features on the ground, to place them in relationship to one another and to a broader topography, revealing patterns to the eye, or, we might say, to create geographies. Like maps, such patterns can be produced and viewed with an eye to scientific objectivity, accurately representing and documenting actual space, or they can be made and read artistically as creating and revealing formal compositions and patterns of light, colour and morphology. These two roles are not mutually exclusive, as will be apparent throughout this book, and both draw on basic cognitive abilities.

The Aerial View and Human Cognition

The average time that a person stands in front of a painting in an art museum, even a famous work, is a matter of seconds. Watch people in the presence of an aerial photograph at the same institution, and they will often spend minutes in front of it, puzzling out details and seeking

to recognize what it is they are seeing, particularly if they think they can locate sites familiar to them. On a wall in the Department of Geography at the University of California at Los Angeles (UCLA), for example, is a large air photograph mosaic of the Los Angeles urban region produced by the Fairchild aerial photography company in the 1960s. At various places the 4×3 feet print has been worn away by countless fingers indicating locations familiar to visitors and students, such as the UCLA campus, Hollywood Boulevard and Disneyland. This engagement with the image is not true of all photographs, and the reason is related to why the bestselling photography book of all time is Arthus-Bertrand's compendium of aerial photographs. The attraction of the air photo and its apparent naturalness may have less to do with aesthetics and more to do with neurophysiology.

To view the world from above seems to be an innate human ability that is activated when we are very young. From the moment a child first picks up an object and tries to turn it in its hands, it begins to develop the skills to rotate first the micro-environment – things that are smaller than the body – and, with time, the macro-environment. The former allows the child to grasp, and thus to learn by feel and touch, those objects that are smaller than the self, and to understand and remember them as discrete wholes with a gestalt that is greater than its parts. Once a child learns, for example, to recognize a wooden block as such, it can recognize another block from afar even without touching it. And this coordination of eye, body and brain allows it to know the form of that other block from all angles. With age, that ability extends to things larger than our own bodies, to the macro-environment, and we learn effortlessly to view space from a myriad of imagined view-points. We transfer that early ability to feel an object in our hands to seeing from different angles the room in which we sit, the house in which we live, our neighbourhood and eventually anywhere we go and even places we merely glimpse in a picture or conjure out of listening, reading or imagining. This capacity to picture places might be called the 'geographical imagination', and it finds its most immediate graphic expression in maps, plans and architectural drawings. It is one of our most basic methods of transforming space into place – that is, into known and

meaningful locations and environments. It is also a fundamental navigational skill essential to survival.

When we see an unfamiliar house from the outside and then enter it, even though the cultural context may be radically different in its particulars, we already know approximately the rules that govern its proportions and something of its layout because these are determined in large measure by the scale and physiological demands of the bodies that occupy and share it. We can make our way around it because we've been in other houses and can envision how this one might be similar. The same is true for the broader landscapes whose topography is measured by eye and body, and of humanized spaces, which contain multiple sensory cues about where we can and cannot go. Despite quite dramatic variation in both natural and cultural landscapes that can disorient us and render us uncomfortable, we are able to function effectively in an astonishing variety of diverse environments, in large measure through an ability to picture space, or, put rather differently, to 'map'. When showing aerial photographs of their neighbourhoods to pre-schoolers who had never before seen such images, researchers in the 1960s were surprised that the young children were already able to put their toy cars on them and navigate their way home from various places in the picture. Anthropologists likewise have recorded showing aerial photographs to Aborigines in Australia who had also never before confronted such representations of their world from above. The indigenous people could find their own location on the photo and navigate virtually through the country, even to places known to them only through anecdote and not through actual visits. The aerial imagination is not something that is learned from flying or even from climbing to elevated viewpoints. Indeed, it may even have been stronger before the experience of actual flight. Our recently acquired ability to soar through the air has simply rendered as a physical experience that which we could already do in our minds.

Among all the views we can obtain of our macro-environment, including being able to imagine the spaces behind things, the view from above is among the most useful, since it allows us to plan ahead, to place ourselves in the larger context of the world and map out a course in both

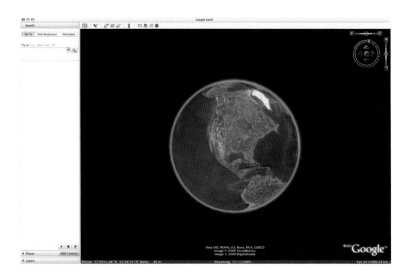

3 Google Earth image.

space and time. The fundamental utility of the aerial view is why we are so attracted to the examples in the museum – we can't help looking at a view that we know carries such important information. That holds true for aerial photographs whether they were made for mapping, conducting warfare or art. This cognitive skill may account for the popularity of the aerial image, whether it be a map, air photo or screen view on Google Earth© (illus. 3), and suggests that photography may be a more significant novelty than flight itself.

The Aerial Image: A Prehistory of Photography

Although aerial photography is less than two centuries old, its prehistory can be traced to the earliest landscape image so far discovered: an imagined aerial view of the late Neolithic village of Çatalhöyük in Turkey (illus. 4) Sometimes described as a map, the image anticipates the two modes of aerial vision: the vertical perspective taken at 90 degrees to the earth's surface that flattens the third dimension in favour of plan and pattern; and the oblique view, looking downwards at an angle, which may be greater than 45 degrees from the horizontal (high oblique) or less (low

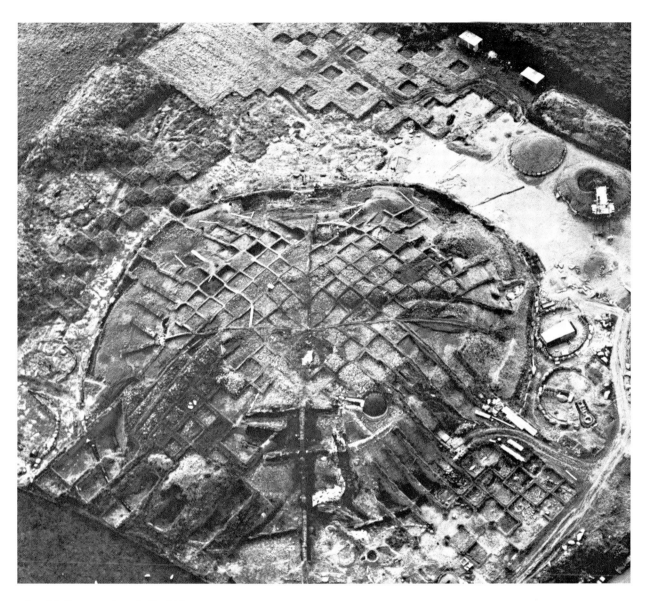

4 Çatalhöyük, excavation of a Neolithic
village in Turkey.

oblique). The oblique image allows for topographic forms, vegetation, buildings and other three-dimensional elements to be observed. It is more akin to the perspective of a landscape painting, while the vertical image more closely resembles a map. The higher the point of elevation above the surface, of course, the greater the possible area shown, but the more even an oblique image flattens elevation and comes to resemble a vertical perspective, the more abstract it becomes. The fifteen-foot-long wall mural fragment excavated at Çatalhöyük has been called both the first map and the first landscape painting. Given the significance of aerial views for the science of archaeology, there is a certain appropriateness that the first aerial view comes from an archaeological site.

Despite the fact that the people living in Çatalhöyük 8,000 ago had no access to flight, nor even a nearby hill from which to look down over their landscape, they were able to conceive of their village from an imaginary point equivalent to hundreds of feet above the ground. A loose plan of their town is inscribed in the mural as a series of squares that correspond remarkably to the pattern of houses and alleyways uncovered by excavations. In the background and seen from a low landscape perspective are two volcanoes corresponding to actual peaks visible 60 miles away and the source of obsidian, the settlement's primary trading article and the basis of its wealth. The town is depicted in its geographical and economic context as surely as if a contemporary geographer were sketching it or an aerial photographer snapping it.

The world as perceived from above appears in ancient rock art from other regions of the world, in the paintings of Aboriginal people in Australia, for example, and in early Mughal, Chinese, Persian and Egyptian art. The images are generally of local places and concentrate on holy sites or locations of political power, such as temples, palaces, the gardens of nobles or the tombs of royalty. Although the divinities honoured in these places might be bound to earthly phenomena, the connection that these images and maps suggest with the God's-Eye view, transcending the earth-bound perspective of the human eye, is suggestive. It is notable that similarly sacred sites were early objects for air photography.

Aerial views exist in Western art from well before Filippo Brunelleschi's demonstration of linear perspective in the early years of the fifteenth

century which transformed the western tradition of spatial representation. Examples include Fra Paolino's graphic depictions of Venice and Rome from the mid-fourteenth century, and most remarkably Ambrogio Lorenzetti's fresco cycle that decorates Siena's Palazzo Pubblico, painted between 1337 and 1339. Fra Paolino's woodcut of Venice seen from above and set within the channels of the lagoon is often described as the first map of the city. Its execution may be relatively primitive, but the handling of vertical perspective and scale are assured. Lorenzetti's paintings include oblique views at different angles and are notable not only for their technical expertise but for their secular viewpoint and their inclusion of text quotations and captions explicating their subject-matter: good and bad government of the city and its surrounding countryside.

To enter the Sala della Pace, equivalent to a modern city council chamber, is to feel a little as if one has walked into a three-dimensional view of the Sienese world complete with towns, palaces, fields and far mountains. Three walls are covered in paintings, and although they rise above the head of a standing or seated observer, they give one the impression of being an elevated viewer surveying the space of government. If placed at eye level with the allegories, one would be in the same position as the flying corpse facing the original entrance to the room, which symbolizes the fear that overruns communities under tyranny. In the two frescoes representing the effects of good and bad government in the countryside, the eye is located below the mountain peaks, but above the ground, at a low oblique angle, thus embedded in the landscape: flying through it rather than at the infinite distance above it adopted by the cartographer. The councillors debating in the chamber would have been elevated enough to see the regular fields of ripening corn, but not enough removed to miss the smoke of burning houses: the effects of tyranny. The overall effect is thus to make the observer a participant in the landscape and the city that governs it, a vested stakeholder in the good management of both.

Lorenzetti's images of Siena and its countryside perfectly anticipate the idea of *survey* that would be promoted by reform thinkers such as the Scottish architect Patrick Geddes in the early years of the twentieth century. His mappings and schematics were based on the idea of making visible the social and environmental relations that tied a city to its

surrounding region, a concept that can only be rendered visible through the perspective offered by elevation. To demonstrate his ideas, Geddes constructed a high tower in the heart of Edinburgh, and furnished it with observational instruments offering views over city and the surrounding region of Scotland. Geddes's concept of regional survey became a principal tool of planning across the world in the first half of the twentieth century and the newly developed techniques of aerial photography played a key role in providing the necessary documentation. Air photos were often published with annotations explaining planning objectives and argument, for example in the work of the Tennessee Valley Authority in the USA during the 1930s, which generated over 45,000 photographs.

5 Edinburgh: Patrick Geddes's Outlook Tower.

Leonardo da Vinci is commonly credited with advancing the aerial imagination in quite diverse ways. The earliest surviving image we have from his hand, dated 1473, is a view of the Arno river valley made from a hillside above Florence. Like the TVA air photographs of 500 years later, his sketches were intended to assist the city's management of an unpredictable river. Already evident is a fascination with aerial perspective that would be elaborated in his architectural sketches and city maps. Leonardo was a formidable engineer as well as an architect and painter, and in 1493 we see him setting down his ideas for an 'airscrew', a vertically rising flying machine, rather like a primitive helicopter (later abandoned by him in favour of the more stable fixed-wing configuration of a glider). In 1500 he entered the service of Cesare Borgia as a military architect, and his aerial imagination shifted from flying machines to the aerial views they might offer. His 1502 painting of the Italian town of Imola, produced in the context of Cesare's military campaign in the region, is often cited as the first accurate aerial view of a town (illus. 6). In appearance it bears some resemblance to the Çatalhöyük mural, but we know from his notebooks that Leonardo measured buildings and streets on the ground before mentally translating the measurements into a vertical perspective image

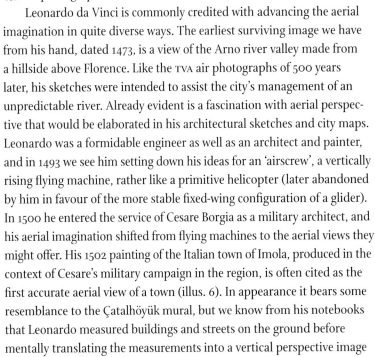

6 Plan of the village of Imola by Leonardo
da Vinci, chalk, pen and paper.

of Imola's plan of streets, squares and buildings, its fortifications and the course of the Sentero river that runs below its ramparts through clearly measured fields. For all its scientific, map-like qualities of orientation, scale and clarity, this is a strongly pictorial image, using colour and shading to generate a feel for the topography.

The background of Leonardo's best-known painting, *La Gioconda* or *Mona Lisa*, a painting he also started in 1502 and finished four years later, is a bird's-eye view of a landscape seen from high oblique with views over mountain peaks and river valleys. In the sixteenth century such grand visions of the earth's surface stretching away to a distant horizon became popular not only as background but as the subjects of paintings in themselves, in South German and Flemish art especially. Sometimes referred to as 'world landscapes', these images by artists such as Albrecht Altdorfer and the elder and younger Bruegels anticipate some of the 'aeropaintings' that would be produced by Italian Futurist artists in the 1920s in response to the new perspective offered by powered flight (illus. 7). Leonardo recognized one of the chief difficulties that would face aerial photographers seeking to capture images of the earth over long distances: the effects of atmosphere on light and vision. In his paintings he deployed

what he would call in theoretical discussions of painting 'atmospheric perspective', a progressive shift in the colour of increasingly distant landscape towards the blue end of the spectrum as contrasts between an object and its background diminishes and colours are less saturated, because light is scattered by water vapour, smoke and other particles in the atmosphere. Aerial photographers would later learn to use colour filters in order to compensate for these effects.

An increasingly secular and commercial Europe required accurate measurements of the world and realistic depictions of it. Lorenzetti's secular, albeit allegorical cycle, did not follow the medieval convention of setting action in an idealized landscape, but used the actual topography around Siena. Leonardo's *Vista of Valdichiana*, an aerial map made during 1503–4 of a shallow lake in southern Tuscany, like other topographical images he produced, used shaded relief and specific contours to give a visual impression of physical relief as seen from above, depicting individual summits, an advance over the stereotypal molehills of the time that indicated mountains. The hilly terrain of central Italy lent itself admirably to the development of the bird's-eye view, but it was equally popular in flatter regions of the continent, for example in Flemish art and cartography. The techniques of 'relief shading' on the topographic maps developed by sixteenth-century artists assume a light source located at one corner of the image (by later cartographic convention, the north-west) that throws the topography into light and shadow, thus allowing it to stand out to the eye in three dimensions. Relief shading would be refined by cartographers, most notably in mountainous Switzerland, well into the early twentieth century, when aerial photographs taken at times when the low angle of the sun produced sharp relief contrast were used to assist in the preparation of such maps. The use of pairs of overlapping air photographs viewed through a stereoscope allows relief to stand out under un-shadowed conditions but is far less practical for

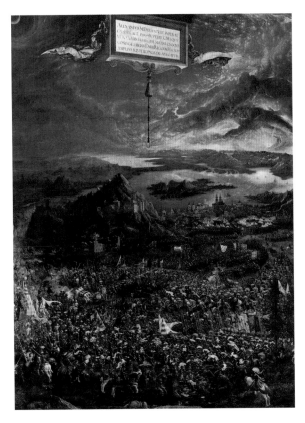

7 Albrecht Altdorfer, *The Battle of Alexander and Darius at Issus*, 1529, oil on panel.

18

most purposes than a relief-shaded map. It is notable that shaded, bird's-eye view maps regained popularity in the closing years of the nineteenth century and the early years of the twentieth – precisely the early years of aerial photography – after losing their appeal to more 'scientific' representations (showing relief by means of measured contours and spot heights) during the eighteenth century. The view offered by balloons – and later, aeroplanes – both generated and responded to a very strong appeal for realistic images of the earth from above.

Like landscape images, the earliest compendium of topographically accurate city views also dates from the late fifteenth century. In 1486 Bernhard von Breydenbach, a wealthy canon of Mainz cathedral, recorded his 1483–4 pilgrimage to Jerusalem in a published work, *Peregrinatio in terram sanctam*. He hired the artist Erhard Reuwich to accompany him, and as they passed through Venice, Corfu, Iraklion, Modoni and Rhodes en route to their destination in the Holy Land, Reuwich sketched elevated oblique views to record the overall layout of each site. His most memorable prospect is a panorama of Palestine stretching from Jerusalem south to the Red Sea, made from a vantage point high over the Mount of Olives, which still affords the best view of the city today. The *Peregrinatio* became a best-selling work, and its woodcut views of cities helped to create a demand for similar images, often by citizens seeking to celebrate the wealth and beauty of their own city. Perhaps the most celebrated is the Venetian engraver Jacopo de' Barbari, whose large woodcut map of Venice in 1500 uses similar shadowing techniques to those being developed for topographic maps to bring individual buildings into sharp relief with extraordinary accuracy. The map has been directly compared against air photographs and modern maps of Venice, and its distortions have been shown to correspond to the need to emphasize key public spaces and locations in the city. The genre of bird's-eye view maps and panoramas of individual cities culminated in the magnificent *Civitatas orbis terrarum*, the first volume of which was published by Braun and Hogenberg in 1572 and that claimed to offer individual views of the world's – in fact, mainly Europe's – major cities (illus. 8). At the publication of its sixth and final volume in 1617, it included an astonishing 546 city images, and its popularity prefigured that of aerial photography albums of cityscapes.

It is worth considering why aerial views of cities were so sought after, anticipating the continuous popularity urban photographic views have had since they first became available. Certainly civic pride and the fierce competition for high visibility among European centres of trade played a part, as they still do in urban image-making. Birds-eye views were of little practical value for merchants and other travellers, for whom written guides were beginning to appear. Multi-volume works such as *Civitatas orbis terrarum* and even individual (and costly) printed views were intended for studies and libraries and as wall decoration rather than to be carried around. Views and panoramas satisfied an aesthetic desire: they decorated walls and were looked at, shared and admired. Just as aerial images today share space with maps and paintings in private homes, the demand was for either views of one's own city or of places with which one had a connection (through having lived or visited there, or family connections). They allow people to *place* themselves, to conceive of the larger environment in which they live, offering a satisfying sense of experiencing a familiar place from an unfamiliar and all-encompassing perspective. We might conjecture that as cities grew it was becoming more difficult to look from the centre of a town, or down a street to the sea or the open landscape, and thus to envision one's

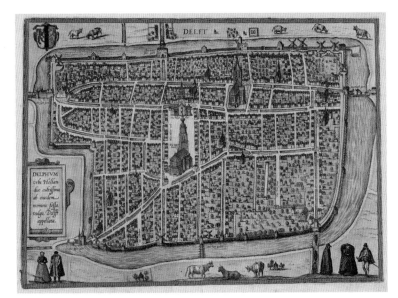

8 A map of Delft by Braun and Hogenberg, 1590.

place in the world, and that urban images allayed this loss. Also, printing and the wide availability of secular images allowed people to become more sophisticated and confident in reading and interpreting images for themselves, rather than having the rare stained glass and frescoed images they encountered in churches interpreted for them. Both these developments stimulated a cultural extension of sight and new ways of contextualizing place. The birds-eye or aerial view responded to this, rendering one's city an object that could be held in the hand and seen in its entirety. As we discuss below, the synoptic view did have one very practical value – to military strategists. Models, plans and birds-eye views of cities and defences were among the earliest and most sophisticated aerial images, as Leonardo's Imola map exemplifies; and in this too their use perhaps anticipates the principal stimulus to the use and development of air photographs.

The invention of lithography in 1796 by the German Aloys Senefelder opened the door to mass-produced, affordable, multicoloured prints. Bird's-eye views were among the most reproduced: thus aerial perspective and modern urbanism became closely linked, and nowhere more so than in those countries that were being colonized by Europeans during the nineteenth century, notably the United States and Australia. In the years between 1820 and 1890, as America's prairies and Great Plains were being settled by immigrants from across Europe and other parts of the old world, the bird's-eye view came into its own as a mode of both documenting and promoting newly appeared townships. While the percentage of people in the United States living in towns greater than 8,000 persons was less than

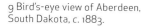

9 Bird's-eye view of Aberdeen, South Dakota, *c.* 1883.

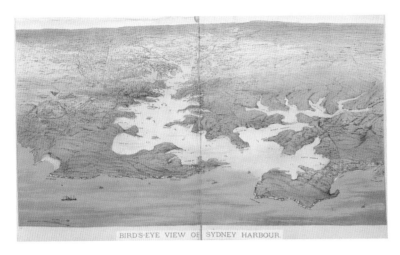

BIRD'S-EYE VIEW OF SYDNEY HARBOUR

10 Bird's-eye view of Sydney Harbour, in the album of the Boileau family's voyage from England to Australia in 1894–5.

10 per cent in 1820, by 1890 it was over 30 per cent. Individual lithographs and county atlases consistently used the high oblique aerial view as a way of suggesting order and regularity in a recently 'conquered' landscape (illus. 9). Long views composed what were often little more than scrabbled collections of wooden cabins, dirt roads and railroad halts into neat order among carefully fenced and tended fields. Over 4,000 views of 2,400 settlements had been produced in America by the 1920s when aerial photography supplanted lithographs and revealed through the unbiased lens the less than orderly reality of such places.

The most commercially successful printmaking firm in nineteenth-century America was Currier & Ives, who sold nearly one million prints. Among their most popular were bird's-eye views of great cities such as New York, Chicago and San Francisco. These were edited into books, and the cities' extraordinary growth meant that new views were regularly required for successive editions. Similar panoramas of cities such as Melbourne and Sydney in Australia, and Cape Town and Johannesburg in South Africa, provided citizens with a record of their colony's success (illus. 10). These images offered templates in their perspective and emphases, and created a market for the aerial photographs of cities that would replace them in the early twentieth century.

22

The First Air Photographs

Three centuries after Leonardo sketched his ideas for rotary and fixed-wing aircraft, the dream of human flight was actually achieved by means of the hot-air balloon. As early as 1709, the Brazilian priest and naturalist Bartolomeu de Gusmão petitioned King John v of Portugal for recognition and protection as the inventor of an airship consisting of a sail stretched over a hull and lifted by heated air. He demonstrated his ideas the same year by floating a model to the top of the Casa de Indias in Lisbon, but was prevented from further experimentation by the Inquisition. His idea would not be pursued successfully until two young owners of a paper mill in France began in 1782 to experiment with paper bags heated over a fire. Joseph Montgolfier was contemplating how the French could invade British-held Gibraltar by means other than potentially disastrous incursions over water or land, and with his brother Etienne began to build larger models built of silk for strength, but still lined with paper to contain the air. They gave their first public demonstration in June 1783, sending a *montgolfière* to a height of 6,562 feet over the marketplace at Annonay (illus. 11). Less than two weeks later two other Frenchmen made the first untethered lighter-than-air craft, using a rubber-coated silk balloon filled with hydrogen, and in August Etienne conducted the first public demonstration of an unmanned balloon flight over Paris. Shortly thereafter he conducted a flight in the presence of Louis xvi and his court, sending aloft a rooster, a sheep and a duck, to 1,700 feet. On 21 November the young amateur scientist Pilâtre de Rozier and cavalry officer Marquis d'Arlandes flew in a *montgolfière* for 25 minutes, crossing the river Seine and becoming the first humans to experience untethered flight. Balloons quickly spread throughout Europe, and in 1793 the first free balloon flight was made in America.

To the long and close connection between military strategy and the aerial view could now be added manned flight, and very soon photography. In 1784 the French army sent up the first aerostatic reconnaissance balloon, and they were used during the 1794 conflict with Austria. A company known as the *aérostiers* was formed as an observer corps to direct battles from the air, often by means of rapid sketches of the battlefield and

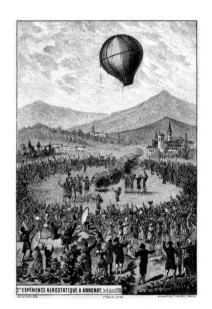

11 Joseph and Etienne Montgolfier's balloon demonstration at Annonay in June 1783.

23

campaign theatre that were then transferred to the ground by sliding them down a cable (illus. 12). These gave the French a strategic advantage in the early years of Napoleon's campaigns and were rapidly copied by other nations' militaries. It was in France too that Louis Daguerre sought to develop a method of imprinting a photographic image, announcing his invention in 1839, and within a year Dominique François Jean Arago, a French geodesist, was proposing the use of photographs in the preparation of topographical maps. He recognized the technical problems of accurately coordinating locations on the photograph with their corresponding points on the ground and on a base map whose scale rarely matched that of the photographic image. Within a decade of the daguerreotype technique being made public, Aimé Laussedat, an officer in the French Army's Engineer Corps, implemented Arago's suggestion, and by 1851 had worked out early photogrammetric techniques for accurate mapping from air photographs. These were based on the same principles as triangulation in survey: establishing a selected point from two separate locations and plotting the lines of sight (or rays) in order to establish the third coordinate and thus fix the location in space. Account has to be taken of geodesic measure relating to the earth's curvature and of the continuous change in scale away from the focal point of an aerial photograph if it is to be used for mapping, which demands consistency of scale across the area shown. To be used cartographically, aerial photographs have to be coordinated with ground survey, a procedure known as 'ground truthing', and still necessary in making use of remote sensed images from space today. Within five years of Laussedat's work, the photographer and balloon enthusiast Nadar (Gaspard-Félix Tournachon) filed for a patent to make an aerial survey using overlapping photos.

Nadar, born in Paris in 1820, started out as a freelance caricaturist and took his first photographs in 1853. The following year he opened a

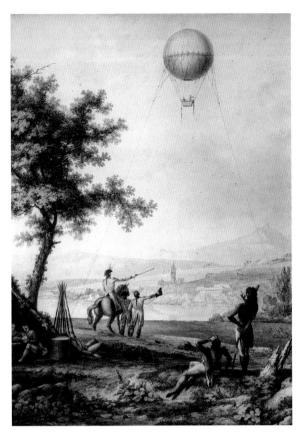

12 The siege of Mainz 1793: balloonist spotters in the First Coalition army observing the city held by French Revolutionaries.

24

13 Nadar, *Aerial View of the Arc de Triomphe and the Grand Boulevards, Paris, from a Balloon*, 1868.

studio in Paris, which in 1874 would be rented out to a group of painters who mounted the first Impressionist exhibition there, an indication of the close association that would continue between pioneers of flight and aerial photography and artistic interest in the effects of light and atmosphere on vision. After patenting his aerial survey technique in 1856, Nadar began to attempt photographing from a balloon, making four unsuccessful tries before finally capturing a successful image in 1858 while tethered 80 metres above the village of Petit-Bicêtre just outside Paris. Sadly, that image does not survive today, and the earliest one that we have by Nadar from the air was taken over Paris in 1866 (illus. 13). In the same year Laussedat managed to send a glass-plate camera aloft with a kite to take photographs for mapping purposes, and a new era of aerial image-making opened as the long-evolving interest in representing the earth from above could be realized in the technological union of human flight and a mechanized means of graphic representation.

two

The Camera in the Sky

The early history of air photography, like that of most other nineteenth-century technologies, does not have a simple lineage. Its techniques were explored, and the experiments by which it evolved took place, simultaneously and competitively in different countries and among different individuals not always in contact with one another. The one consistent strand in the story is the significance of military interest, involvement and adoption. Like map-making, obtaining accurate photographic and other remote sensed images of the earth from above has, from its earliest days to the present, been a preoccupation of state and military strategists. Portraiture dominated early photography as a terrestrial medium; war has dominated photography in flight.

As Nadar, Laussedat and others in France experimented with cameras in balloons, Napoleon III and his senior officers understood the strategic significance of their work. In 1859 the emperor negotiated with Nadar over 50,000 francs to take aerial photos in the war against Austria in Italy. While their discussions came to nothing, it was in that year that Nadar first developed a rudimentary photogrammetry, using aerial photos taken at different angles to plot the position of objects on the ground. The technique is the foundation for stereoscopic aerial photography, the primary tool for scaling and accurately interpreting topography and ground features. It would be widely used for uncovering the military camouflage and trenches which were becoming features of army uniform and strategy in these same years. The bright colours and opposing infantry formations that had traditionally characterized soldiers' dress and military confrontations gave way in the later nineteenth

century to ways of obscuring troops and ground: dun colours in dress and digging a front into the earth as a protection against explosive shells.

The American military followed developments in flight and its potential for imaging the battlefield as closely as any other. Benjamin Franklin had witnessed the first Montgolfier flights in Paris and noted the potential use of the aircraft as a device for reconnaissance. As hostilities commenced in the Civil War, J. W. Black, fresh from his 1860 success in photographing Boston, recommended the Union Army use aerial photography as a reconnaissance tool. In 1862 Lincoln's army did send up a captive balloon to observe Confederate troop positions, and some of the flights may have included a photographer. The practice was discontinued when the Southerners discovered they could simply shoot down the balloons, and no photographs have ever surfaced to confirm actual deployment of a camera. Nonetheless, the military value to commanders on the ground of a synoptic view of the battlefield obtained from the air was demonstrable, and other nations' militaries followed these early attempts with considerable interest.

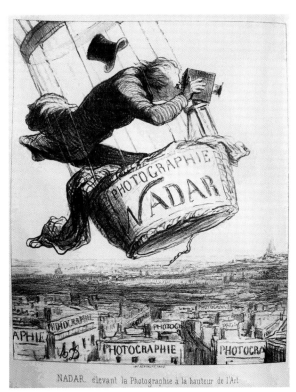

14 Honoré Daumier's cartoon of Nadar the balloonist.

NADAR. élevant la Photographie à la hauteur de l'Art

Nadar himself continued his experiments with aerial photography, launching an enormous balloon, Le Géant, in 1863 to capture dramatic images of Paris, then under reconstruction according to the plans of Baron Haussmann. The balloon became Nadar's calling card (illus. 14), and was the inspiration for his friend Jules Verne's *Five Weeks in a Balloon*, an imaginative tale about exploring Africa from the air that anticipates one of the principal and continuing uses of air photography: virtual exploration and making remote and inaccessible locations visible to the eye. The balloon was also used by the American John Scott, who patented a system for sending a camera aloft in an unmanned inflatable, initiating the purely mechanical recording of the earth that now dominates remote sensing technologies. An alternative craft was the kite, first used by the British meteorologist E. D. Archibald in 1882 but hampered

27

by the weight of equipment it carried. An improved system was pioneered in 1888 by the Frenchman Arthur Batut, who used a string of kites to bear the weight of the camera attached to the last of them. The camera was equipped with an altimeter to determine the height at which the exposure would be made, allowing the photograph to be accurately scaled. A system of burning fuses and taut rubber bands opened the shutter, while a small flag was raised by the moving shutter in order to indicate to 'ground control' when the image had been captured and the kite was ready to be lowered. Over a number of experiments during which the various interacting devices were modified, Batut succeeded in obtaining some remarkably clear low oblique air photographs of the village of Labruguière and the Tarn River in south-west France. Kites would be used to spectacular effect by the American George Lawrence, a Chicago studio photographer who in classic *fin-de-siècle* hyperbole claimed to specialize in 'The Hitherto Impossible in Photography'. Among other novel photographs, he made bird's-eye city views from balloons, and later multiple kites. His most celebrated work is the panorama of San Francisco made shortly after the 1906 earthquake, a view assembled from shots taken by cameras suspended above the ruined city from as many as twelve kites. This dramatic perspective of the scale of devastation wrought

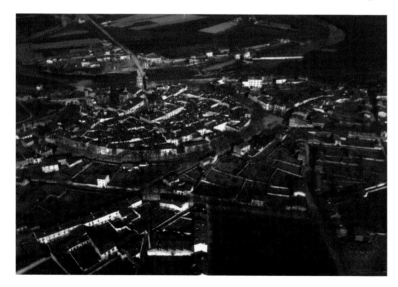

15 Arthur Batut, *Labruguière*, aerial view from kite, altitude 230 metres, 1896.

28

on the city was reproduced in newspapers around the world. The image earned him $15,000, almost certainly a record for a single photograph at that time, and inaugurated the use of aerial photography as a medium for covering such large-scale news events.

By the 1880s aerial photography was capturing the attention of a broad public, at least in France, and its applications beyond military reconnaissance were being recognized. Gaston Tassandier published *La photographie en ballon, avec une table* in 1886, the first textbook on photographing from the air, and Batut himself authored the classic handbook of early aerial photography in 1890, *La photographie aérienne par cerf-volant* (*Aerial Photography by Kite*). Batut envisioned a broad application for air photographs: for studies in geography and exploration, in archaeology and in agriculture, as well as in military reconnaissance. Of continuing – and growing – significance is the use of aerial images in recording and measuring changes in the earth's surface. In 1888 the Bavarian mathematician and geodeticist Sebastian Finsterwalder started a project to re-photograph Swiss glaciers from balloons, enabling him to observe their advances and retreats and alterations to their mass balance. Such images provide a baseline for today's measurement of glacier retreat, and repeat photography has become a key technique for measuring the effects of global climate change as well as more mundane environmental history, such as that of landscapes in the American West that were originally photographed for railroad construction in the late 1800s and re-photographed in the 1970s. Despite the wide variety of civilian uses to which Batut accurately believed that air photography would be put, its military value remained paramount, and would be the principal stimulus to its development as powered flight came to replace balloons and kites as the principal vehicle for the airborne camera.

The Camera and Powered Fight

The world's first air force had been established by Napoleon in 1784, the year after the Montgolfier brothers flew their balloon over Paris; Benjamin Franklin had not been the only person to notice the relevance

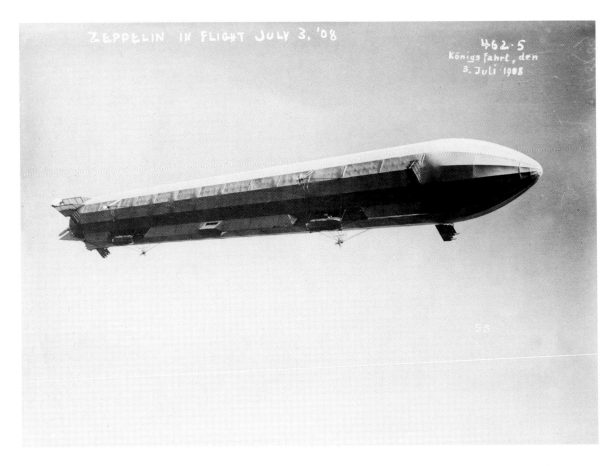

Text in image: ZEPPELIN IN FLIGHT JULY 3, '08 — 462·5 Königsfahrt, den 3. Juli 1908

of the flight to strategic advantage. Napoleon was so impressed by the pilot of an aerostatic reconnaissance balloon reporting that he was able to spy telescopically on a town 18 miles distant that he formed the small balloon corps that played a role in his victory at Battle of Fleurus later that year. Although the French corps was later disbanded, in 1849 the Austrians attempted the world's first large aerial bombardment, reconnoitring the defences of the short-lived Venetian republic and sending 200 unmanned balloons towards the city. The venture was only partially successful because, while some of the timed devices did hit the city, other balloons were blown back over the Austrian lines by a shifting wind direction. As the Union Army's experience confirmed in the American Civil War just over a

16 Zeppelin in flight, 3 July 1908.

decade later, any military use of flight needed powered and guided aircraft in order to make aerial reconnaissance or bombardment in warfare a practical option. But the obvious advantages of reconnaissance from the air prompted the Germans to establish a balloon corps in 1884, and the Russian army promptly followed, developing in 1889 aerial survey cameras that used a seven-lens fixed system for making overlapping pictures of the ground. Versions of this technique, which is the basis of stereoscopic photogrammetry, would provide the most accurate pictures of the world from above until satellites were deployed during the Cold War in the twentieth century.

Ferdinand von Zeppelin, who as a young German officer had been an observer during the American Civil War, had been impressed with the use of balloons above the front. He was also acutely aware of their limitations, realizing that the key to the widespread use of aircraft in war would be a system of propulsion. Determined to solve the problem,

17 Henri Lartigue, Deauville, 1919.

by 1899 he had developed the first rigid-frame dirigible powered by a propeller. Zeppelin airships were used to bombard British cities from 10,000 feet in 1915 and they carried cameras, although British success in using more manoeuvrable biplanes to shoot down the slow airships quickly made airplanes the principal aerial platform in warfare and also for aerial photography (illus. 16).

The Wright brothers first flew their aircraft at Kitty Hawk in 1903, but the serious photographic dialogue between airplanes and the ground began when the nine-year-old Jacques-Henri Lartigue took a photograph of their first successful public flight in France. Lartigue, who would become one of the century's most celebrated early photographers, continued to photograph aerial spectacles at the Issy-les-Moulineaux airfield in the years before the Great War, and as new airplane designs took their maiden flights (illus. 16). Also a painter, Lartigue became friendly with a number of modern artists, many of whom were equally fascinated by flight and its implications for transforming conventional ways of seeing and representing the world. Matisse, for example, lived close to Issy-les-Moulineaux and visited it regularly to watch air shows, along with such artists as Picasso, Braque and Delaunay. All of them marvelled at the speed and power of the machines and at how powered flight made a new view of the world possible, and modernist painters quickly took to the air and recorded their experience in paint.

Italian Futurists in the late 1910s and '20s particularly pursued this theme, using airplanes and vertiginous aerial perspectives to promote the displacement of nature by technology and to record the combined experience of flying and seeing the ground in ways beyond the capacity of the static photograph. Artists such as Filippo Tommaso Marinetti, author of a number of Futurist manifestos, were fascinated by photography but regarded its static qualities as a decisive limitation on its artistic potential. 'Photodynamism', a technique developed in 1911 by Anton Giulio Bragaglia with Marinetti's financial support, was a Futurist attempt to overcome this limitation by drawing on the chronophoto-graphic techniques initiated by the American Eadweard Muybridge's 1890s images of the human body in movement. Photodynamism sought to capture movement and the sense of vertigo and disorientation that

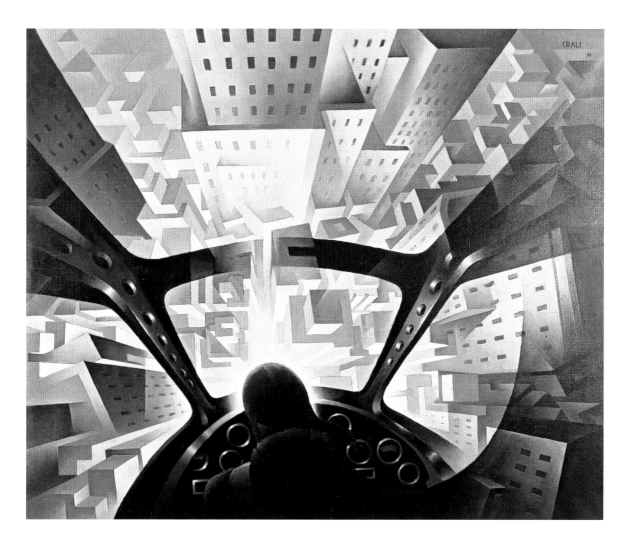

18 Tullio Crali, *Dive on the City*, 1939, oil on canvas.

flight can produce but that, given the film and shutter speeds available in the first decade of the twentieth century, could only be captured on film as a blur of light and dark. It is uncertain whether Futurist artists ever made use of air photographs in preparing their *aeropitturi*, although the painter Tullio Crali actually became a stunt pilot (illus. 18).

The first recorded photo actually taken from an aeroplane dates from 1908, when the Pathé cinematographer L. P. Bonvillain, flying with Wilbur

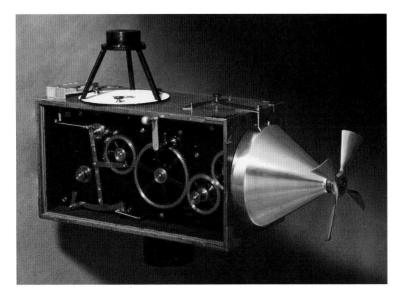

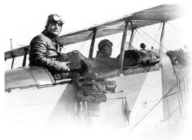

20 World War I era aerial photography enabled by a side-mounted camera on an open cockpit biplane.

19 Model F aerial automatic film camera, 1915–21.

Wright near Le Mans, France, reproduced a still from his motion picture film. Although film and shutter speeds, as well as the low altitudes of early aircraft, prevented good resolution in early air photographs from flying machines, this precursor signalled the point at which the dialogue between air and ground grew infinitely more complex. Aerial spying could now be directed and much greater areas covered. Coupling propulsion with photography meant that a strategist could direct a flight over a potential target and record it for detailed study once back on the ground. The strategic advantages thus offered were to be rapidly realized in the great European conflict that opened in 1914. By this time the technologies of film speeds and camera shutters had been rapidly advanced by commercial companies such as Eastman Kodak, whose dry film technique and hand-held Brownie had revolutionized popular photography. At the opening of the war reconnaisance photography from airplanes flying over enemy territory allowed military planners to track over the course of a few hours or days the movement of troops and their supplies, and the build up of manufacturing, at multiple sites, and to adjust strategies accordingly. Aerial bombardment could be more accurately targeted and its effects measured. On the other hand, enemy fighting aircraft rendered unfettered

34

reconnaissance from the air impossible, and opposing sides in a conflict were henceforth obliged to hide their resources from cameras in the sky. The need to camouflage troops, vehicles and military supplies from aerial sight came into sharp focus along the war's various fronts, and the exchange between air and ground expanded to a game of hide-and-seek in which technologies advanced and were rendered obsolete with increasing rapidity.

At the beginning of the war Germany held the lead in aerial reconnaissance technology, with advanced cameras placed aboard Zeppelins. When the French discovered a camera aboard the remains of a downed Zeppelin in 1914, they quickly activated a photographic section within their own air corps. Britain was slower to adopt the new technology, and the Royal Flying Corps lacked any aerial cameras at the start of the war. Frustrated observation pilots carried personal hand-held cameras with them in order to take snapshots of the trenches being dug by the enemy. It became rapidly obvious that the cameras caught more detail than the mind could grasp in flight, and that repeat

21 An aerial view of the Fortress of Herodium.

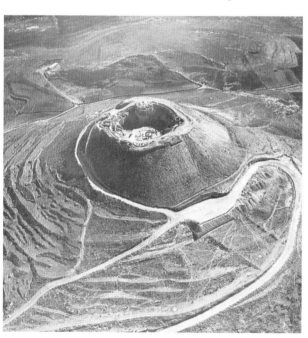

photography over an area allowed changing patterns and deployments to be ascertained, measured and even anticipated. Once their commanding officers understood the value of these images, the British put resources into developing specialized cameras for attaching to spy aircraft (illus. 20). They quickly developed stereoscopic cameras using gravity-fed magazines mounted to the fuselage of airplanes (illus. 19). The Germans, who deployed up to 2,000 mapping cameras of their own in the air, and were photographing the entire 450 miles of the Western Front every two weeks in the final year of the war, were so threatened by these British inventions that they began mounting machine guns on their Fokker monoplanes specifically for the purpose of bringing down the British reconnaissance planes.

35

Archaeology

In an unexpected synergy, archaeology and warfare became intertwined at this point in the evolution of aerial photography. Time is arguably the most effective camouflage agent, inexorably eroding and destroying things and merging them into the broader environment, making it increasingly difficult to discern figure from ground, be it the original shape of a ruined building or city, former agricultural fields and boundaries or earthworks and diggings. But such activities do leave traces, and with elevation these can become evident to the eye as surface changes in colour or shadowing. For both archaeologists and military strategists the aerial view offered the opportunity to discern patterns, and the monochrome photograph often emphasized these variations in light and shadow quite markedly (illus. 21).

Among the first to recognize the archaeological significance of the aerial view was the American balloonist John Wise in 1852, as he floated over Native American earthworks near Chillicothe, Ohio, a site now recognized as a national monument. Although nearby mounds had been known to Europeans since their arrival in 1796, Wise noticed new lines on the ground, and directed archaeologists to their investigation. The mounds, constructed by the Hopewell culture some time between 200 BC and AD 500, were difficult to interpret at ground level, but from the air their outlines and the patterns of ceremonial architecture became obvious. But systematic application of aerial photography to archaeology only began in the early twentieth century, and aerial archaeology was intimately linked with military aviation in its initial decades.

The first photographs of standing archaeological ruins were three images taken over Stonehenge from a tethered balloon in 1906 by Lieutenant Phillip Henry Sharpe of the Royal Engineers' Balloon Section, a group stationed little more than a mile from the famous megalith. What these photographs revealed of the overall layout of the monument was so startling in its clarity that they were published in the journal *Archaeologica* the following year (illus. 22). Two years later the Italian army began to photograph Roman ruins from the air, part of the Liberal government's attempt to connect a modernizing and forward-looking Italy to its glorious past. While the Italian aviator Captain Tardivo was taking the first mapping

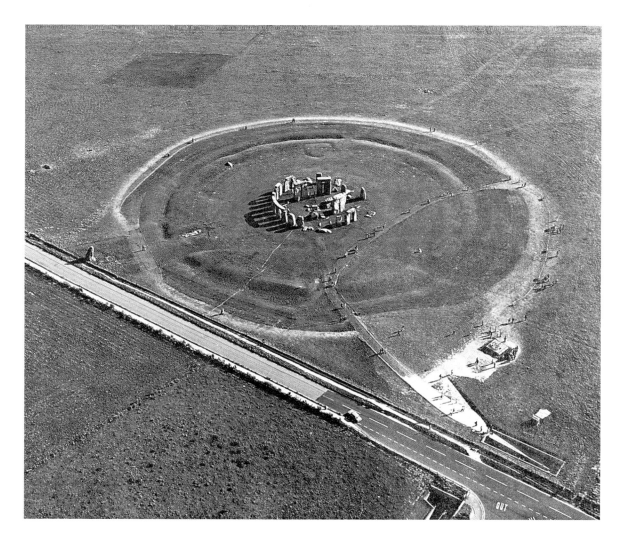

22 Stonehenge in a recent photograph.

photos from an airplane in 1913, Sir Henry Wellcome was using cameras suspended from kites to document his excavations in the Sudan.

The British alone produced a stunning 6.5 million aerial images during just the last year of the Great War, and it was perhaps inevitable that some of them would reveal heretofore undiscovered archaeological sites. For example, Colonel G. A. Beazeley, conducting aerial photo reconnaissance over ancient Mesopotamia – soon to become Iraq – discovered the ruins

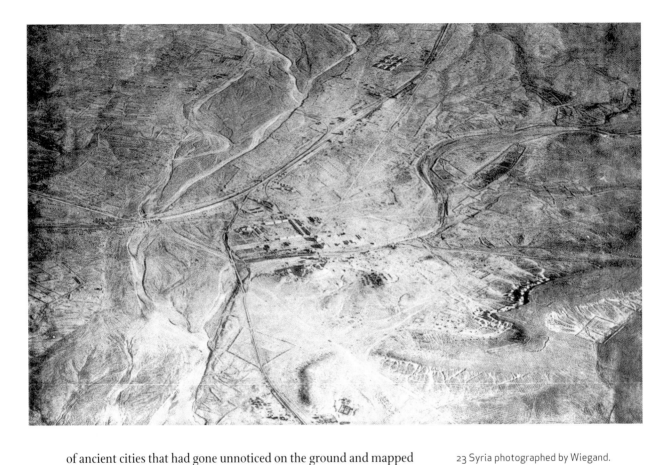

of ancient cities that had gone unnoticed on the ground and mapped the outline of ancient Baghdad. The number of aerial photo runs made by the Germans was so high that the archaeologist Theodor Wiegand convinced pilots of the Asia Korps late in the war to photograph archaeological sites that interested him as they made their routine reconnaissance. Wiegand insisted that the pilots note as precisely as possible the time and location of individual photographs, and from what angle, direction and altitude they were taken. The resulting images remain an invaluable record in a region of the world where continuing conflicts have destroyed or altered many of the ruins (illus. 23).

Osbert Guy Crawford was an English wartime pilot trained in geography at Oxford under one of Patrick Geddes's disciples, A. J. Herbertson.

23 Syria photographed by Wiegand.

24 One of Osbert Guy Crawford's photographs of Wessex.

38

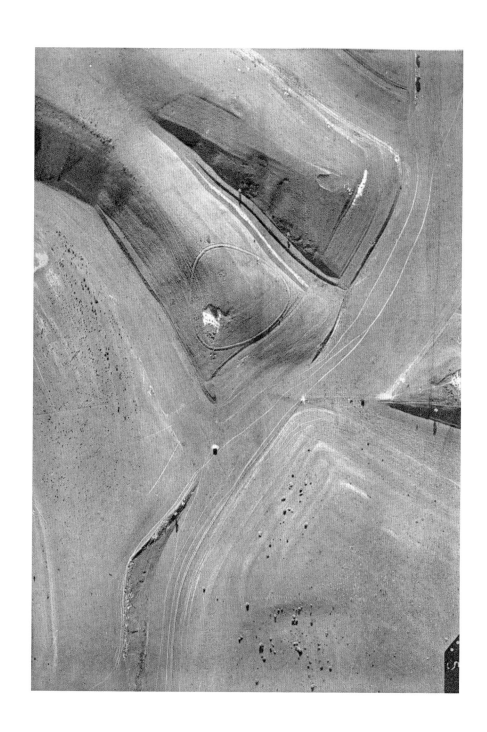

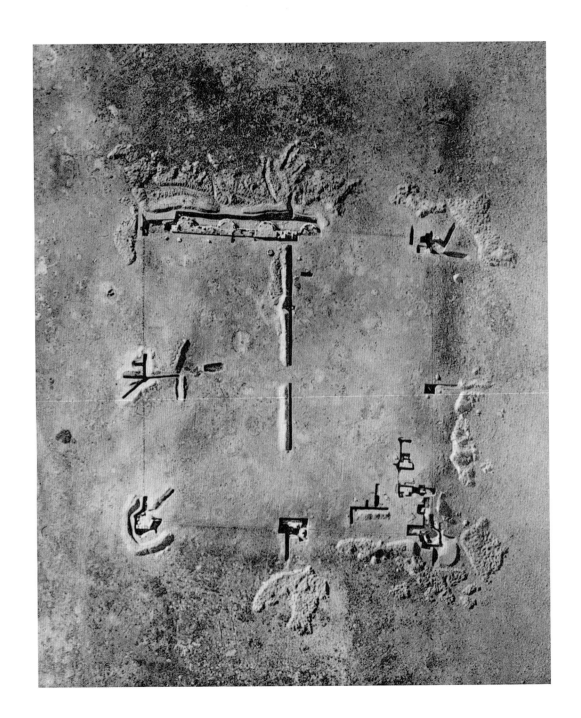

26 A US Army aerial photography unit with a three-lens camera, c. 1920s.

25 A photograph by Antoine Poidebard of a site in Syria.

As a young graduate Crawford had worked with Wellcome in the Sudan before serving as a cartographer with the army and an observer with the Royal Flying Corps. In 1922, while working as the Archaeological Officer of the British Ordnance Survey on military aerial photos of Southern England taken during the war, he noticed alternating light and dark stripes in cornfields that could not be accounted for by any variations in planting. Given their location in the most densely settled region of Neolithic Britain, Crawford, who had studied early Celtic settlements in the same area, recognized the patterns as disturbed earth, evidence of human occupation that was completely invisible from the ground. Crops growing over old ditches, where the soil was deeper, tended to have lusher foliage, absorbing more light and thus appearing darker than crops growing on shallower, less disturbed soil. Crops growing over old walls, where the soil was shallower, appeared lighter.

In 1924 Crawford began a systematic aerial survey of Wessex, a region already known for its archaeological sites, and used the 300 photos it produced in order to direct excavation of the sites. His 1928 book, *Wessex from the Air*, with its 50 illustrations, became the foundational study of aerial methodology (illus. 24). The Frenchman Antoine Poidebard, who had flown over the Middle East during the war, was also at work in aeroplanes, and with a commission from the French Geographical Society undertook an aerial survey of Syria in 1925, tracing ancient Roman roads and irrigation systems from his biplane. While Crawford often used oblique panoramic photographs to reveal shadows cast by features such as aligned stones, Poidebard relied more on vertical shots that proved better for outlining ancient infrastructure (illus. 25).

The New World was also being scrutinized from the air. Although the Americans had been far behind their European counterparts in aerial reconnaissance when the US entered the war in 1917, they quickly established a School of Aerial Photography at the Eastman Kodak Company in Rochester, New York, and the Photographic Section of the American Expeditionary Forces for overseas work. In command of the latter was the famous fine art photographer Edward Steichen, who would serve in the Second World War in naval photography. Between the wars, the American Army Air Corps shrank dramatically, but nonetheless the US maintained

41

an Aerial Photographic Research facility in Ohio where early research into more advanced technologies, such as telephoto and infrared photography, was conducted (see illus. 26).

Systematic surveys such as Crawford's, using aircraft to photograph extensive areas along predetermined transects, became a feature of inter-war aerial photography, increasingly used for resource mapping and planning (illus. 100). It was of particular value in areas where surface transportation networks were not developed and access difficult. Thus, for example, much of Peru, in particular its Pacific coastline, was photographed from the air by a US Navy pilot, Lt George R. Johnson, who was seconded as Chief Photographer to the Peruvian Naval Air Service between 1928 and 1930. Based on ground features appearing in the images, he was later recruited by the geologist Robert Shippee to undertake an aerial survey of the whole country in 1931, an effort that produced some 3,000

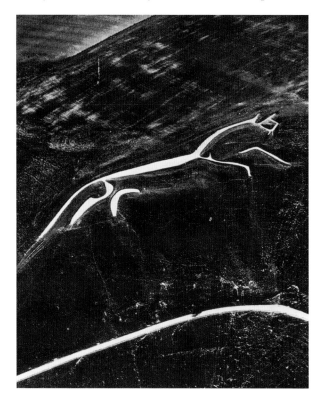

27 The White Horse of Uffington, a tribal badge on downland in southern Britain, c. 1200BC–800BC.

42

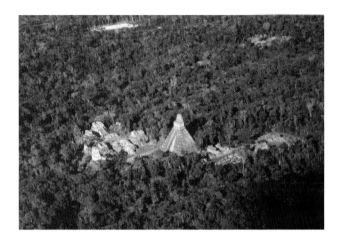

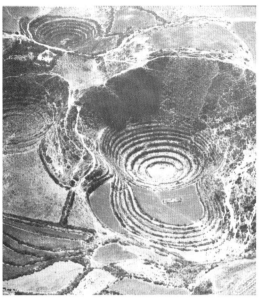

28 Tikal, the Great Plaza from the southwest. A Mayan site in modern-day Guatemala.

29 Amphitheatres at Muyu Uray in Peru.

vertical and oblique images. These included the first aerial images of Peru's most celebrated archaeological monument, the ruins of Machu Picchu, first reported in the West only 20 years earlier. During the same period, the two commercial airline companies Faucett and Panagra begin flying passenger planes over the deserts and mountains of Peru. Pilots and passengers noticed lines on the coastal pampas region of Nazca, later to be surveyed by Paul Kosok, who along with his colleague, the German archaeologist Maria Reiche, would make them among the most famous earthworks in the world. The varied images formed by these geoglyphs are carved at a scale that renders them coherent only from the air, and, like the Çatalhöyük drawings, raise intriguing questions about the human ability to project oneself imaginatively into space and 'see' the world from above.

Interwar Air Photography and Survey

The ending of World War I injected a surplus of pilots and planes into civil aviation. Although small planes on short runs were being used for

passenger flights as early as 1914, for flights across Florida's Tampa Bay, for example, it was 1918 before serious commercial flights began to be offered. Ten Handley Page biplane bombers were converted to carry twelve passengers apiece on the London to Paris route, and the era of air travel began in earnest. At the same time, cameras were becoming easier to operate for ordinary people. The earliest photos taken in flight had required large wet glass plates to be developed in the basket of the balloon within 20 minutes of exposure. The first dry plates, permitting post-flight film development, were taken up in 1879. The introduction of Kodak roll-film cameras in the 1880s, and then the widely affordable Brownie models in 1900, offered a technology that anyone flying as a passenger could use to take aerial photos. It was, in fact, an airman flying in a Wright biplane over San Francisco in 1911 who had used a borrowed Kodak to test successfully the idea of documenting strategic targets from the air for the American military. Inevitably, Kodak cameras became popular in the interwar years among air passengers seeking to record the novelty of the view from the air.

The 1920s and '30s witnessed the rapid development and expansion of aerial activity of all types. Germany experimented with long-distance, passenger-carrying dirigibles; distance records for solo flights were constantly broken by male and female flyers, such as Charles Lindbergh in the United States and Amy Johnson in Britain; and writers such as Antoine de Saint-Exupéry romanticized the French airmail route

30 Santiago, Chile, a view from Santa Lucia Park, c. 1920s.

connecting Paris to Rio de Janeiro via Dakar and the French African colonies. A similar explosion of aerial photography followed. Lindbergh, himself a former mail pilot, married Ann Morrow, whom he taught to fly, and the couple promptly began to explore and record the world from the air. They flew low over Chichén Itzá to probe the ruins, and their photographs were published in the *New York Times*. Their elevations were too low to allow them to discover new sites, and they didn't discipline themselves to a search grid and transects, so their results were of limited

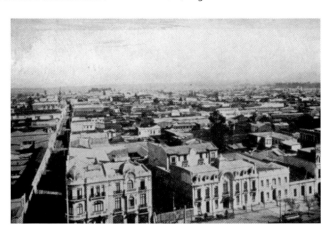

44

use to archaeologists – but the flight inspired many would-be explorers to take to the air with a camera. In the case of other sites, such as the ruins of Angkor Wat in Cambodia, the airborne camera allowed details of carvings on the upper parts of structures that were inaccessible from the ground to be recorded and studied.

Less well known are the thousands of images taken by the German aristocrat Count Wulf Diether zu Castell-Rüdenhausen, who flew for more than three years over China, undertaking the first aerial record of that country. A French military expedition had taken some balloon photographs of the country in 1902, but his systematically organized photographs are still being used today for archaeological research. Even the most distant corners of the planet were becoming accessible to the aerial eye. In 1928 George Hubert Wilkins, a pioneering aviator from Australia, and his co-pilot Carl Ben Eilson flew for thirteen hours over the Antarctic, covering 1,300 miles in the first flight over the continent, 1,000 of which were over new terrain. They sketched and took photographs the entire way, and Wilkins noted in his diary that 'For the first time in history, new land was being discovered from the air.' Aerial photography would later become a weapon in the international competition to claim rights over Antarctic space. Such surveys were also used increasingly for documentation and planning in populated and well-mapped territories for commercial and planning purposes. Geologists in 1920 started making aerial surveys for oil companies, and the us Forest Service was documenting America's coastlines with seaplanes. Erosion studies, agricultural assessments, land use practices and the counting of both domesticated and wild animals all were new uses for aerial images.

The popularity of bird's-eye views of nineteenth-century American cities shifted in the early twentieth century from hand-drawn lithographs to air photographs, which increasingly became a way that Americans came to see and know the places they occupied and could document the ever increasing urbanization of their population. A number of former pilots lent their expertise to developing commercial enterprises in order to answer the demand for aerial photography. These businesses offered large-format images for sale, counting on the continuing fascination that

45

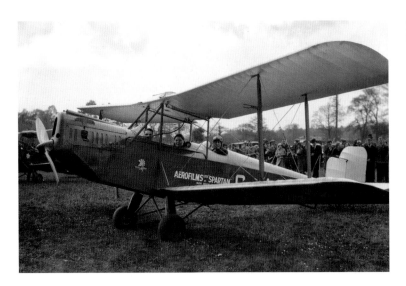

31 Aerofilms Spartan three-seater plane at an air display in April 1933.

we have for seeing our homes, neighbourhoods, offices or properties from the unique perspective of the air. Air photos were increasingly sold for advertising, real estate development and tax assessment purposes. Among the most successful commercial air photography firms were Aerofilms in the UK, founded by F. L. Wills and Claude Graeme-White in 1919 (illus. 130), and Fairchild Aerial Surveys, founded the following year by Sherman Fairchild. The intrepid although somewhat frail photographer, born in 1895 in upstate New York, started his aerial career during college by climbing onto the roof of Soldier's Field in order to photograph the Harvard football team in action. In 1918 he visited the US Army's aerial photo school in Rochester to see if his camera expertise would be of use, and began to design camera equipment for military reconnaissance. He sold his first high-speed aerial cameras to the military the next year, and in 1920 invented a shutter that worked at a high enough speed to eliminate the distortions caused by the increasing ground speeds of aircraft seeking to record the landscape. The company Fairchild founded would eventually produce two kinds of cameras, one for vertical survey work, and another for more interpretative oblique views.

In order to create demand for his product, Fairchild delivered aerial photos of breaking events to newspapers by aeroplane, pioneering the

32 Sherman Fairchild, *Glendora Orchards*, California, 1931.

33 Sherman Fairchild, *Dominguez Oil Field*, California, 1930.

46

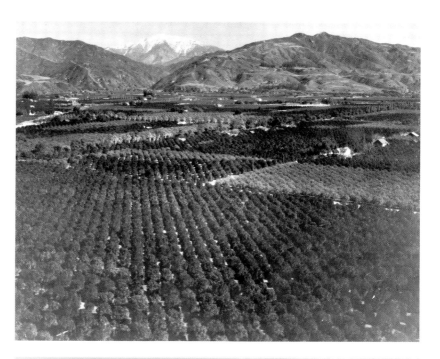

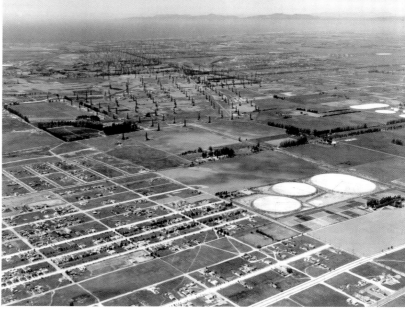

application of such speed to journalism. Hired in 1921 to document the rapidly changing skyline of Manhattan, he made the first aerial photo mosaic of the island, covering 24 square miles in 69 minutes. Cities such as Kansas City, Missouri, and Los Angeles commissioned him to photograph terrain for the purposes of urban planning, and his images were widely reproduced in the comprehensive but ultimately ignored 1930 Olmsted plan for greater Los Angeles. Fairchild did so much work over the sprawling Southern California megalopolis that he opened a separate office in LA in 1924, switching his company's emphasis from manufacturing cameras to selling photos. Southern California was then America's most rapidly expanding urban region; with its nascent aircraft industry and fine weather, it became a key centre for commercial air photography (see illus. 32 and 33). Fairchild was soon rivalled by the Spence company, which also extensively documented landscape changes in the region until the mid-1970s. When the architect Norman Bel Geddes was chosen by General Motors to design the *Highways and Horizons* exhibition for the 1939 World's Fair, he studied Fairchild's aerial photographs of Los Angeles's burgeoning highway system for inspiration in how to design his model cities and their superhighways – automated freeways – for his city of the future. Viewers rode in more than 300 chairs mounted along a conveyor belt and looked down upon what was soon known as Futurama, the most popular attraction at the fair. The Fairchild and Spence companies bequeathed to the world an astonishing documentary record of twentieth-century urbanization patterns. By 1935 Fairchild's archive already contained 200,000 aerial images, the largest private and commercial collection in the world.

The photos made by Fairchild, Spence and others contributed in large measure to the disappearance of lithographic bird's-eye views, but at a cost. Photographs are exhaustive in their detail, but they are undiscriminating, unselectively recording every feature in the landscape that is capable of reflecting light to the point from which the image is captured. Lithographs, like all designed maps, are selective and composed for the purpose of offering a more legible graphic interface with the ground. Hand-drawn lithographs would retain their popularity as tourism images, while the aerial photograph became the cultural standard for veracity, and the foundation for topographic map-making.

When the Great Depression halted much of the real estate development that had funded his work, Fairchild was hired by the War Department to shoot the length of the Missouri River from the air, and in 1929 he undertook the initial aerial survey work in preparation for constructing the Hoover Dam. The Department of Agriculture became aware in 1930 that the topsoil covering thousands of square miles in the Plains was being lost to windstorms and deposited further east, and its Soil Conservation Service hired Fairchild to document the formation of what would soon become known as the Dust Bowl. To undertake his aerial survey over the vast stretches of the Great Plains, Fairchild built the largest aerial camera ever constructed, a 300-pound instrument that, when flown at 23,000 feet, could capture 225 square miles per exposure.

The Dust Bowl has become an iconic event in American twentieth-century history in large measure through the work of photographers who documented it in still and moving images. Some of the country's most celebrated photographers – Dorothea Lange, Walker Evans, Gordon Parks and Arthur Rothstein – worked under the direction of Roy Stryker for the Farm Security Administration (FSA), which was created in 1935 to record the unfolding environmental disaster and its social consequences. Their images largely shaped the public understanding of it. While Fairchild's survey photographs may have been more objective, they offered a less dramatic record than the remarkable and intrepid Margaret Bourke-White. She started her career as an architectural photographer, and practically invented the photo essay as a journalistic form while working subsequently for magazine magnate Henry Luce. She took her first aerial photographs in 1934 while working on a series about the Dust Bowl for *Fortune* magazine, recognizing that this was a geographical event too large in scale to be captured by any other means. The following year Trans World Airlines hired her to document points of interest along their transcontinental routes, thus reinforcing the increasingly aerial view of the world that Americans and Europeans were beginning to assimilate. Many of Bourke-White's iconic images, such as 'New Deal, Montana: Fort Peck Dam', which appeared on the cover of the first issue of *Life* magazine in 1936, were both narrative and aesthetic.

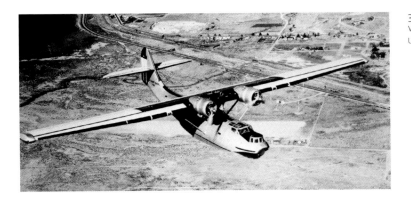

34 A Consolidated PBY-5 Catalina (08055) V-189 used for aerial photography by the US Coast Guard in 1941–3.

The Midwest and the Plains were familiar to American from an aerial perspective through the popular bird's-eye views of the previous century, and also from barnstorming flights offered to locals by ex-military pilots working the county fair circuit. Pursuing FSA goals of familiarizing Americans with the consequences of the farm crisis and thus garnering support for New Deal policies, Stryker had photographers in the air as early as 1936 to take pictures that would establish a regional context for the people and towns within which he could juxtapose pictures of life on the ground, allowing air photography to take the place of the map in creating a popular understanding of geographical relationships. At the same time, the Agricultural Adjustment Administration (precursor to the US Department of Agriculture) began to conduct aerial photo surveys over farmlands across the Dust Bowl states in order to check farmers' compliance with production and soil conservation controls. Planting practices and ploughing along contours were immediately detectable from the air across large areas. According to the geographer Mark Monmonier, the farmers mostly accepted what some could have deemed intrusive surveillance; after all, the agency was using methods based on those developed by the military for aerial photo-interpretation. But the monitoring was tied directly to cash subsidies for land held out of production, and the State was seen by many in a benign light as the saviour of rural life, so that resistance was muted. In 1937 the 'AAA' had 36 crews in the air photographing 375,000 square miles, and by 1941 they had documented more than 90 per cent of the country's fields. By this time,

50

another world war had begun, and the likelihood of America's involvement was high. The US Army and Air Force absorbed both Stryker's unit and the AAA personnel and its two photo laboratories, and the military adopted the aerial imaging techniques refined over the Midwest, later applying them to conquest and reconstruction around the globe.

Similar developments in aerial survey and applications were occurring in Europe and other parts of the world, such as Latin America and European overseas possessions, where air photography greatly assisted colonial surveys. In British East Africa, for instance, soil conservation measures developed in the Dust Bowl were soon applied, using air survey to determine appropriate areas. By the late 1930s Fairchild was selling cameras around the world for military and colonial photography, and the company itself was conducting surveys from Japan and China to South Africa and Peru. As Thomas Campanella puts it in his book about the company, *Cities from the Sky*, Fairchild was to aerial photography what Ford was to cars. In hypernationalist Germany, where National Socialism was combining a complex (and contradictory) vision of modernity based on advanced technologies such as aircraft, automobiles and highways with a conservative ideology of German identity rooted in the country's traditional rural landscape, Eugen Diesel, son of Rudolf and inventor of the Diesel engine, published a comprehensive survey of the countryside, *Das Land der Deutschen*. The book included 481 aerial photos, most of which were by Robert Petschow. The book was so popular that an affordable mass edition was published in 1933, perfectly illustrating the vision of Germany promoted by the new regime. Perhaps the most celebrated propaganda movie of all time, Leni Riefenstahl's *The Triumph of the Will* (1935), which celebrates one of the vast Nazi rallies at Nuremberg, opens with a long sequence of the Führer's plane passing through clouds over which appear views of a peaceful and settled German landscape and the ancient streets and squares of Nuremberg. The affect is a powerful union of the mastering gaze of the dictator and the shared nationalist vision of a harmonious landscape. It was a landscape whose devastation in the coming decade would be planned and documented photographically from the air.

three

The Airman's Vision: World War II and After

The wartime pilots who had taken cameras aloft during the 1914–18 war were part of a small elite of military flyers whose dangerous and often lethal missions were commonly pictured in the public eye as modern incarnations of medieval jousts among knights of the skies. The romance of flight endured through the early decades of the twentieth century, so that World War II fighter pilots – especially those flying alone in fighter planes – still projected the air of knightly chivalry. The 'airman's vision' (discussed in detail later in this chapter), to which some American writers in the early days of the 1939–45 conflict referred when picturing the post-war world, called upon this trope, imagining that the clarity and purity of the pilot's view of the earth captured in air photography allowed for a better, more unified world to be created from the disaster of war. World War II was indeed in larger measure than any other major conflict fought with manned aircraft, but it was the bombers and logistical planning based on aerial reconnaissance more than the romantic fighter planes that determined the outcome, and it was these larger aircraft and the control systems devised for them that shaped post-war commercial developments in flight and democratized the view from above. Emphasis on the knightly 'airman' also ignored the growing place of women in the air. From the 1920s women pilots and the cause of women's political and social emancipation became closely aligned, and the US Army began to recruit women air photographers for reconnaissance and mapping missions during World War II.

Interwar Developments

The decade leading up to World War II saw significant advances in both photography and flight. While Kodak roll film and inexpensive cameras had made snapshots a mass phenomenon in the opening years of the century, the first high-quality 35mm camera, the Leica, was introduced in 1924, and in 1929 the handheld, medium-format Rollei appeared, giving photographers a greater variety of formats and film types to choose from. In 1935 Kodak introduced the first commercial colour film, and within a year Kodachrome was being used worldwide. While most professional photographers working in the air continued to use black-and-white film in large-format cameras, the increasing numbers of ordinary people experiencing flight, either as commercial aircraft passengers or holidaymakers taken aloft for a 30-minute thrill, were taking snapshots of the ground below with their hand-held cameras. Increasingly, aerial views were being used in movies as establishing shots for locales such as New York City. Flight was becoming more affordable and the aerial view increasingly familiar if not yet banal, not least through photographic reproduction in newspapers and specialized photo-journals using high-quality image reproduction.

Flight itself was undergoing even more profound changes as its technology rapidly advanced. New records were constantly set and broken in the 1920s and '30s, both in distance flown and altitude reached. Greater distance allowed ever more remote parts of the earth's surface to be photographed from the air, greater altitude, for ever wider expanses of space to be pictured (see illus. 35). Thus in 1935 a pioneer of military aviation, Captain A. W. Stevens, with companion O. A. Anderson, reached the stratosphere at a height of 74,000 feet in a helium balloon over South Dakota and captured the first photograph to show the curvature of the earth. Powered flight was also advancing rapidly. About the time that colour film began to be sold in drugstores and chemists, aircraft engines were being supercharged and modified to burn the newly available leaded fuel. This dramatically boosted speed and power while lowering the volume of fuel that had to be carried, thus allowing for more cargo and passenger weight. It also meant that

aeroplanes could fly at full power and speed up to and over 30,000 feet, putting them above the reach of anti-aircraft batteries. This would become crucial in wartime for photoreconnaissance planes, which typically were not armed.

America's size and ample resource base stimulated the early development there of widespread commercial air travel. Improvements in cabin technology, such as soundproofing, and the introduction of the Douglas DC-3, which cut long-distance flight times in half, lured businessmen into the air, and air passenger miles increased almost 600 per cent during the 1930s (although the number of passengers at the end of the decade still equalled only 7.6 per cent of those taking long-distance train journeys, which cost less than a third per mile of airplane fares). In 1939 ninety per cent of the world's commercial air traffic was carried in DC-3s, a plane that would be used as the initial cargo backbone by the American military during the war in the following decade. The largest European carrier was Germany's Lufthansa. Until 1937, when the hydrogen-filled *Hindenburg* exploded, the primary commercial aircraft used in Germany were lighter-than-air vehicles (airships), which could carry relatively few passengers. After the fiery catastrophe, reproduced around the world in photo-journals and on newsreels, airplanes came to dominate the German commercial fleet. Lufthansa was a state company used in part to get around sanctions on German rearmament, and by 1939 was annually carrying more passengers than all other European airlines combined. The company's operations were swiftly and completely militarized with the onset of war. The transition from a burgeoning commercial aviation industry back into a military one was virtually seamless in both America and Germany.

35 The northwest side of Mt Shasta, California, photographed by Captain A. W. Stevens of the Army Air Corps.

World War II Air Photography

All the nations that would become embroiled in World War II recognized that aerial photography would play a crucial role in the coming conflict,

54

and their national militaries were developing aerial reconnaissance well in advance of formal hostilities. Developments in both flight and photography made for a much more systematic approach to the work. The British Air Intelligence service, for example, had started clandestinely photographing Western Europe, in particular Germany, during the late 1930s, while the US Army Air Corps started teaching its first aerial reconnaissance classes at Lowry Field in Colorado in 1938. When America entered the war in 1941, Edward Steichen was pressed back into service as the director of the Naval Photographic Institute, and his younger colleague Beaumont Newhall, who had established the first Department of Photography at New York's Museum of Modern Art in 1940, followed the older man's advice and found a position in photoreconnaissance. Virtually every film and camera producer in America, Germany and Japan was recruited to meet wartime needs, giving professionals in those countries the pre-eminence as innovators and manufacturers of photographic equipment and supplies that continues to this day.

The global nature of the mid-century conflict stimulated rapid technological advances in aerial photography. In the North African theatre, for example, where aerial photography played a critical role in organizing the great tank battles, the desert environment posed special challenges: dust storms often obscured visibility, and the German Luftwaffe developed dark-yellow filters to counter the effects of light reflecting from sandy surfaces, and hardening materials in the development process to prevent the film coating from melting. Dustproof vehicles were necessary for developing film and keeping destructive microbes at bay. Other equally demanding environmental challenges faced air reconnaissance and photography in the Pacific War. Overall, by 1944 American flights in the various war theatres were producing as many as 3 million photos each month. In German-occupied Europe, the struggle for command of the air in the months leading up to the invasions of southern Italy and Normandy was as much about gaining access to comprehensive photographic coverage of potential sites for landing large troop numbers as attacking enemy facilities. The Sicily, Anzio and Normandy landings of 1943 and 1944 and the slow, bloody advance through the South Pacific islands all depended on detailed prior aerial

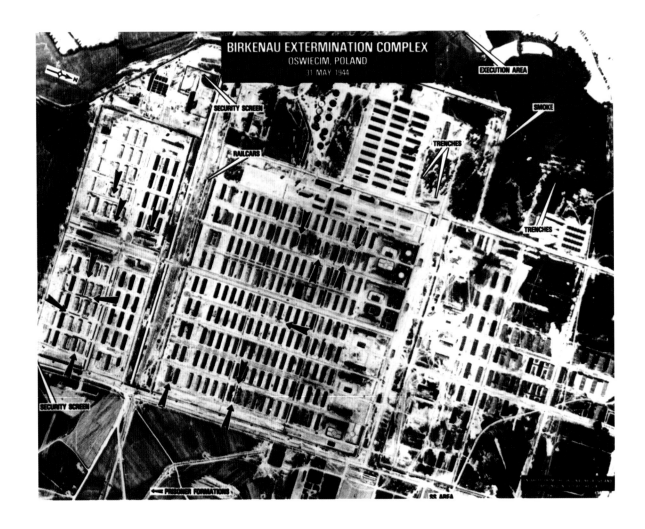

BIRKENAU EXTERMINATION COMPLEX
OSWIECIM, POLAND
11 MAY 1944

EXECUTION AREA

SMOKE

SECURITY SCREEN

RAILCARS

TRENCHES

TRENCHES

SECURITY SCREEN

PRISONER FORMATIONS

SS AREA

reconnaissance and the analysis of air photographs by trained experts
in photogrammetry. Overlapping traverses run by aircraft flying as
low as possible (given enemy anti-aircraft operations) were studied
and mapped onto topographic sheets at military planning bases
and used for operations management, while during the action itself
constant updating photography was undertaken from the air (illus. 36).
Many of those trained in air photographic interpretation during the
war turned their skills in the post-war years not only to commercial

36 A reconnaissance photograph of
Birkenau (Auschwitz) concentration camp
taken by the US Air Force, 1944.

56

photography and cartography, but to artistic use. Douglas Huebler, for example, who became a major figure in 1960s conceptual art, using photographs and maps in much of his work, learned photogrammetry and mapping techniques from studying aerial photographs for the US Navy during the Pacific war.

But it wasn't just the military that was photographing wartime action from above. In 1943 the photojournalist Margaret Bourke-White became the first woman to fly on a US Air Force combat mission, a bombing raid over Tunis. She went on to fly reconnaissance missions over Italy, and to document from the air the effect of fire-bombings on German towns and cities such as Frankfurt, Nuremberg and Mainz (see illus. 37). Although employed by the photo-journal *Life*, the US Strategic and Technical Air Forces also used her images for analysis of damage. Aerial photography also played a significant role in educating the public about the conflict. The theatres of the war were so extensive in area, covering entire oceans and continents simultaneously, that it was almost impossible for people to conceive, much less keep track, of the advance and retreat of various fronts without aerial images, in particular global picture maps. In California, for example, the *Los Angeles Times* staff artist, Charles Owens, drew weekly full-colour maps of the various theatres of war using the image of the globe and the curving horizon to give the impression of actually seeing the vast spaces of the Pacific or Atlantic from high above. Sketches and photographs were collaged onto these maps. Actual aerial photographs of battle zones were rarely used, as they remained subject to military security. More widely available was Richard Edes Harrison's *Look at the World*, an atlas published by *Fortune* magazine in 1943 to educate the American public about the global nature of the conflict in which they were involved. Harrison used the orthogonal projection, abandoned the convention of placing north at the top of his maps and drew upon the relief shadowing techniques developed by the cartographer Erwin Reitz to produce high oblique views of vast areas of the earth, anticipating the photographic images that would only become possible twenty years later through space satellite imagery. His maps illustrated the arguments then being made by political scientists and public intellectuals, such as the poet Archibald MacLeish (who would later write about the first

photographs of Earth from the Moon), that World War II was the 'airman's war'. The airman, he argued, gained a unique perspective of the earth to see things 'as they truly are'. Removed from the petty squabbles and concerns of daily life on the surface, the airman could dream of utopian futures: 'the airman's earth, if free men make it, will be truly round: a globe in practice, not in theory.' In 1946 it was fitting therefore, if ironic too, that the first pictures of Earth as seen from outer space should be taken from a V-2 rocket captured in Germany near the close of the war and fired from the White Sands Missile Range in New Mexico. The black-and-white

37 Wartime view from an American Piper Cub observation plane looking down on Route 6, which runs past German-held Mt Porchia (bottom), around Mt Trocchio (centre) and on to Monte Cassino (background), where the Germans were entrenched in its hilltop monastery. Taken by Margaret Bourke-White, 1944.

photos were taken from 65 miles above the ground by a 35-millimetre motion picture camera, and inaugurated what would later come to be called remote sensing.

Post-war Aerial Photography in Mapping and Planning

The rhetoric of the airman's vision as a shaping force in the post-war world was used by American commercial airlines and educators alike in the years immediately following the end of conflict. Surplus wartime transport planes were readily available to be used for new commercial ventures in flight, while the huge aircraft industry, which in 1945 employed more than a million people in the US alone, building 300,000 military aircraft, was rolled over in large part to the commercial sector when the war ended. The transfer of wartime technology from defeated Germany was as significant for aircraft development as for rocketry. The world's first jet aircraft had been manufactured and flown in Germany in 1939, and the Messerschmitt Company produced a jet fighter during the war. Luckily for the Allies, the planes used too much fuel for them to be viable, and they were destroyed while grounded at airfields. The British, in parallel, invented their own jet fighter, and after the war the two technologies were used by America to field its own jets only months after peace was declared in Europe. While the twin-propeller DC-3 from 1934 remained the principal passenger aircraft into the 1950s, experiments with new technology for commercial aircraft such as Britain's Vickers Viscount turboprop and Comet jet indicated the future for mass air travel, as the problems of thrust versus fuel consumption were overcome and jet aircraft became commercially viable.

Widespread familiarity with the aerial view in the post-war years came not only from actual flights, but also – for most people – from photographs seen in newspapers and journals, and on newsreels and movies. Belief that the aerial perspective had a unique role in shaping a better world was widespread in the years following the war. Aerial photography, which had proved so effective in planning the destruction of cities in Germany and Japan, could now be used for the peaceful reconstruction and planning

59

of post-war cities and regions. This was an exten-
sion of the belief in aerial survey that had emerged
alongside early balloon photography, but it was
much more extensive in both its claims and its use.
One very influential example is the architect E. A.
Gutkind's 1952 text *Our World from the Air* (illus. 39
and 40). Gutkind was a conscious disciple of Patrick
Geddes. Claiming that aerial photography opened a
new dimension to planning that had been unavail-
able when the master opened his Outlook Tower in
Edinburgh, the book contained 400 air photographs
organized to demonstrate Gutkind's argument about
the need for rational planning of human impacts
and transformations of the earth's surface. Twenty-
eight images illustrated 'nature untouched', with
images of floods and erosion. These were followed

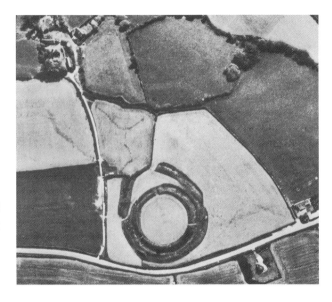

38 Castle Dore, a photograph of a circular
Iron Age hill fort in Cornwall.

by sets of photographs intended to show the destructive capacity of
humans exploiting the environment and each other in warfare, resource
mining and manufacturing industry (although, as critics at the time pointed
out, the images have an aesthetic quality that often seems to contradict
the argument they illustrate). A photograph of New Orleans from 15,000
feet is captioned with the prescient comment that 'Man deludes himself
into the belief that he can play the part of an omniscient re-maker of
his environment.' The book closes with an argument for comprehensive
regional planning, illustrated by aerial photographs of dams and highways
constructed by the Tennessee Valley Authority.

Gutkind's book represents a grand and aestheticized vision of post-
war planning. For the most part, air photography was used much more
practically in planning and development: to map resources and evaluate
topography for infrastructural projects. The military control of air surveys
inherited from the war gave way in the 1950s to commercial companies,
for example in Canada, where aerial survey offered huge advantages over
surface mapping of the nation's huge spaces. Private firms took over the
work in 1956, their work proving critical to such projects as the Trans-
Canada highway, the St Lawrence Seaway and the Labrador rail line.

39 E. A. Gutkind, a diamond mine in the
Transvaal, South Africa.

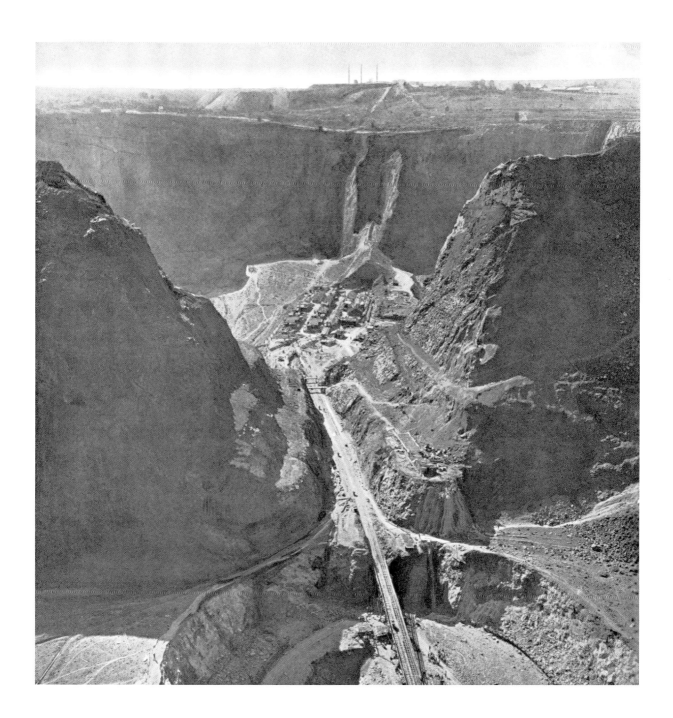

Perhaps the most widely reproduced aerial images of post-war planning and development are a set of photographs taken of an early 1950s private housing initiative in Southern California. Across America, a construction boom responded to the demand to house returning GI's and their young families. The New Jersey homebuilder William Leavitt, who had spent the latter part of the war in the Pacific advising the US Navy Seabees (the Construction Battalion) on the rapid construction of military bases as the Americans hopscotched from island to island, applied his methods to constructing suburban housing. Standardized designs, pre-cut lumber and crews trained to move from site to site and recreate exactly the same construction were the basis of modern housing development. Others followed his lead, and in 1950 a young

40 E. A. Gutkind, The Spiral salt pans, Lake Texcoco, Mexico.

62

41 'Grading Lakewood' in California, photographed by William A. Garnett, 1950.

aerial photographer, William Garnett, flew over one such emerging suburb in Los Angeles while taking the iconic images of what would eventually come to be disparaged as 'ticky-tacky houses', pictures later adopted by an American environmental movement that has ever since relied heavily on aerial photography to help make its case (illus. 41 and 42).

William Garnett was born in 1916 and grew up in the Los Angeles area, taking his first flight as a scenic tour over the city as a child, and

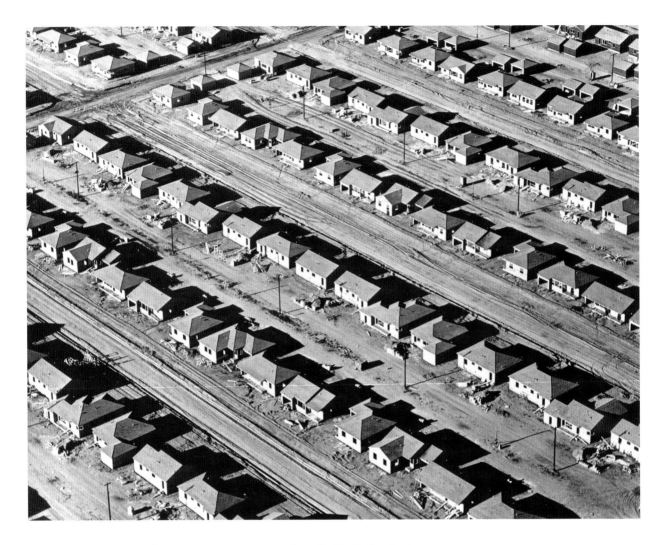

taking an aerial photo of the campus in Pasadena for his high school yearbook. His first job was as an architectural photographer, and during the war he was one of the many artists who found work preparing charts for aerial reconnaissance. On discharge from the US Army, he cadged a berth in the navigator's seat on an otherwise full cross-country military flight back to LA, later crediting the experience for his desires to become a pilot himself, and to focus his artwork on aerial photography. He

42 'Plaster and Roofing', Lakewood, photographed by William A. Garnett, 1950.

purchased an airplane in 1947, and in 1950 was hired by the Lakewood Park Corporation to document the 'instant city' they were erecting near Long Beach – a rapidly growing centre of aircraft production – at the rate of 500 houses per week: 17,500 homes within three years in total. Garnett selected a group of six images that showed the process of construction, from grading the land through laying the foundation slabs and assembling the frames to the rows of completed houses ready for occupation. Reflecting Garnett's modernist, geometrical aesthetic, the views were taken from a low oblique angle in sharply raking light with long shadows, cutting out any horizon. Garnett's pictures captured very effectively the production-line efficiency of a building process which satisfied the needs and the wallets of the 25,000 veterans, mostly Douglas Aircraft Company workers, who showed up on the day that sales opened. Today the city of Lakewood is largely indistinguishable within the vast spread of Los Angeles, a well-shaded, settled and pleasant community woven inextricably into the fabric of the metropolis. The initial plan envisioned a balanced community with schools, a recreational centre and a library incorporated into the design. But environmental and social critics of urbanization viewed Garnett's black-and-white photographs of mass-assembled homes on 3,500 acres of identical building pads and streets as a sterile pattern of sprawl that destroyed both nature and the human spirit.

Following the success of the Lakewood photos, Garnett was hired by *Fortune* magazine to take aerial photos alongside Bourke-White, and was given his first solo exhibition by Beaumont Newhall in 1955. Newhall had relinquished the photography department at New York's Museum of Modern Art (MOMA) after the war to Edward Steichen, and was then director of the International Museum of Photography at George Eastman House in Rochester. That same year, the photographer Ansel Adams and Beaumont's wife, the photographic historian Nancy Newhall, curated an exhibition in Yosemite National Park called *This is the American Earth*, which the environmentalist Sierra Club then turned into its first coffee-table book in 1960, the inaugural title of what would be a remarkably popular series of photography volumes promoting nature conservation. Garnett's aerial photos of Lakewood were at the centre of the book, and

were used to represent the antithesis of nature. Edited by Adams and Newhall, who wrote the captions, and promoted by the influential biologist and environmentalist David Brower, the Lakewood images were presented in the exhibition and book as 'the hell we are creating here on earth', and contrasted with picturesque images of untouched mountain wilderness.

Another major photographic event of 1955 was Steichen's *Family of Man* exhibition, mounted at MOMA. The 503 black-and-white photos from 68 countries were selected from a pool of nearly two million images, and aerial images by Garnett were included in the show. The show was seen by an estimated nine million people in 38 countries and the book has sold more than four million copies. Garnett's and Bourke-White's aerial photographs, along with the widespread use of aerial footage in newsreels, helped make the view from above familiar and increasingly expected in journalism.

Post-war: Global Aerial Reconnaissance

The two decades following the end of World War II saw the decolonization of European empires across much of the world, and the Cold War contest for global supremacy between the USA and the USSR. The former meant that colonial survey offices, which had been primary sources and users of air photography in many parts of the world, were wound down. The British Colonial Survey Committee, established in 1905, for example, had covered the largest range of territory in this respect, and relied heavily on aerial photography. It was closed down as former colonies and dependencies achieved independence in the post-war decades. While some colonial surveys continued to support the mapping agencies of former colonies, the regularity and detail of aerial survey conducted earlier – for example, by the Italians in Libya and East Africa or the French in South East Asia – would not be matched until satellite remote sensing offered global coverage in the 1980s.

However, aerial surveys did play a significant role in one of the last attempts to expand Britain's imperial reach during the 1950s. In 1956

the Falkland Islands Dependency Survey had been created by the Colonial Office with the explicit intention of securing imperial rights over parts of Antarctica that were subject to rival claims by Argentina and Chile; it had done so by producing accurate maps of the territory through a programme of aerial photography of Graham Land and other 'British' parts of the continent. Using Canso over-wing aircraft that had proved their reliability in the Canadian Arctic, the Falkland Islands Dependencies Aerial Survey Expedition (FIDASE) was undertaken by a commissioned private firm, Hunter AeroSurvey Ltd, under the direction of a former wartime bomber pilot, Peter Mott. The intention was to make a high-altitude photographic survey of 42,000 square miles of Graham Land and the Wedell Sea in the course of two summer seasons. The work was difficult and demanding, not only because of poor weather conditions, with frequent fog and mist obscuring the ground and the high reflexivity and deep shadows produced by snow and vertiginous mountain slopes, but also because of the navigational and plotting difficulties produced by magnetic variation and the gathering of longitude lines towards the poles. Despite these difficulties, and the need for ground survey in equally harsh conditions in order to fix triangulation points and verify photographically determined locations, FIDASE produced an archive of 10,000 aerial images that covered 35,000 square miles of previously unmapped terrain before it was abandoned in 1957 because of costs. The photographs include some dramatic as well as beautiful images of the Antarctic peninsula.

The FIDASE survey used no innovative technology in either flight or photography. Such developments were mainly an outcome of the Cold War. The United States military launched the U2 spy plane in 1955 to penetrate freely into Soviet airspace. The plane was capable of flying at an altitude of 70,000 feet (21,336 metres), beyond the range of both radar detection and antiaircraft measures (although, as Gary Powers discovered when he was shot down over Russia in 1960, this would be a fairly short-term advantage). The Polaroid Corporation, which during the war had made the 'vectographs', or stereophotographs used for aerial reconnaissance, notably in preparation for the Normandy and Guadalcanal invasions, created special optics for a large-format camera

that could capture items smaller than a metre across from an altitude of 60,000 feet (18,288 metres). The most widely reproduced aerial photographs taken with this technology were of Soviet missile sites in Cuba in 1962, the product of repeated overflights of the island during the crisis (illus. 43). They represent perhaps the most dramatic example of the role that aerial photography has played as evidence in international affairs, and one which gave the medium a legitimacy in international diplomacy that lasted until Colin Powell's presentation to the United Nations of air images taken over Iraq in advance of the US invasion of 2003. U2 aerial photographs were used extensively during the Vietnam War, and the technology is still in service today because the planes can be deployed more quickly than satellites over specific areas of interest.

43 Cuba: MRBM launch site 2, San Cristóbal, 1 November 1962.

The 1957 Soviet launch of Sputnik, the world's first satellite, was a direct response to U2 overflights that had asserted US freedom of the skies and thus the capacity to bomb Soviet cites with impunity in time of war. Sputnik was launched on an intercontinental ballistic missile, rendering the USA vulnerable to Russian attack. In opening the space race, however, the 1957 launch inaugurated a whole new era in photographing the earth from space. The images thus generated are often credited with playing a critical role in the environment movement which bourgeoned in the 1960s, a subject of the next chapter. In fact, conventional air photography in the 1950s was already feeding the first stirrings of a new way of seeing and thinking about the earth. We have already discussed the critical uses to which Garnett's Lakewood images were put after only five years of their commission as celebrations of the human transformation of the land. Gutkind's aerial survey was also put to use in an early environmentalist publication. The collection of essays titled *Man's Role in Changing the Face of the Earth*, edited by William L. Thomas, Jr, in 1957 was the outcome of a major conference held in 1956 at Princeton and organized by the geographer Carl O. Sauer of the University of California at Berkeley; Marston Bates of the University of Michigan, a distinguished zoologist

68

44 Santa Fe, Spain, 1958.

and environmental scientist; and Lewis Mumford, the principal American spokesman for Patrick Geddes's survey and planning ideas. A summary essay by Gutkind, 'Our World from the Air', opens the printed collection, privileging the high-altitude aerial vision as the principal medium for understanding the impacts of human life and activity on the surface of the earth.

At lower altitudes, aerial observation and photography continued to advance as an increasingly widely used tool of everyday survey and documentation. Companies such as Aerofilms in the UK and Fairchild and Spence in the USA expanded their civil operations. It was only logical that America's premier site for the aeronautics industry, Los Angeles, would become the first city to use police helicopters in 1957; within a year this stimulated local television stations to send up their first news choppers over the vast urban region so they could keep up with the action. Low-altitude police and television surveillance would soon become features of daily life in cities – features as familiar in the last third of the twentieth century as aerial images of environmental crisis.

four

Contemporary Views: Air Photography and Remote Sensed Images

From the late 1950s, as satellites and space flight began to compete with airplanes as sources of aerial photography, photography itself became an increasing part of a larger category of aerial images, at least in terms of most military and scientific applications. It is not just the case that fewer conventional, film-based aerial photographs are being taken; rather, a familiar and well-developed technology has been supplemented and increasingly supplanted by digital images made within parts of the electromagnetic spectrum invisible to human eyes. Higher altitudes from which the cameras operate – for example, from satellites – has meant that generally the images have to be obtained remotely rather than by a human eyewitness, and that the only practical means of retrieving them is through electronic transmission, initially via analogue television, more recently by digital means. Digital cameras have also largely displaced film in conventional aerial photography from aircraft, although the variety of film sizes from which to choose and film's higher resolution and capacity to soften white hues makes it popular for more professional use and among those able to develop their own photographs. The older analogue transmission technology operated by varying the amplitude and frequency of signals being sent; the newer transmissions reduce everything to data sets of ones and zeroes, creating dramatically greater opportunities for interpreting data and manipulating graphic images.

70

Remote Sensing

The Russian scientist N. P. Krinov made the first aerial spectrophotographs of the ground in 1930, and the following year Americans were testing infrared-sensitive film from a balloon in the stratosphere. Infrared film was used on a limited basis for photoreconnaissance during World War II, but as altitudes increased and camouflage became more sophisticated it became more widely used. Of particular value was the capacity to image troop movements at night, and both the U-2 and SR-71 spy planes carried infrared cameras. Any discussion of aerial photography since the early 1960s necessarily includes a variety of technologies, if for no other reason than to define why aerial photography itself remains a valuable technical and aesthetic medium. The varied array of aerial imaging has given rise to a new category of spatial documentation, labelled 'remote sensing' by Evelyn Pruitt early in the satellite era. Pruitt, a geographer working for the US Office of Naval Research in Washington, DC, coined the term to distinguish between aerial views made from airplanes and those made by satellites, the latter optics being more distant from the ground. Today, the term is used more generally to refer to any kind of sensing from above the earth's surface, including conventional aerial photography (illus. 45).

45 Boston, Massachusetts, NASA high-altitude infrared photograph, 1980.

The intense development of rocket engine technology and guidance systems in the late 1950s led to the deployment of intercontinental ballistic missiles that could carry nuclear weapons anywhere in the world, the first truly global weapons system. The only way to keep track of Cold War missile sites was from high-altitude spy vehicles making regular overflights of a rival's territory, which – at least for the United States looking at the Soviet Union – meant from space. This also meant reaching into the infrared spectrum in order to penetrate atmospheric haze, and at the farther end of the

71

46 NOAA aerial photography of damage caused by Hurricane Celia: an airport hangar destroyed and aircraft strewn about, August 1970.

47 NOAA aerial photography of damage caused by Hurricane Camille, one of the most powerful hurricanes ever to strike the United States, August 1969.

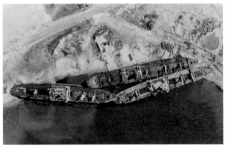

spectrum to use temperature differentials in order to show earth surface variation. Use of infrared also allowed spy photography to overcome camouflage intended to disguise military sites. Both higher altitudes and use of the broader spectrum had been explored in aircraft-based photography before World War II. Taking pictures from rockets had been proposed as early as 1891, and was implemented from White Sands with the 1946 launch of a German V2 rocket carrying a motion picture camera. In addition to the U2, the United States deployed the legendary SR-71 – Lockheed's Blackbird – between 1964 and 1998. Many of the operational details of this spy plane remain classified, but it functioned most efficiently at speeds greater than Mach 3, and from over 80,000 feet in altitude (more than 15 miles or 24 km above the surface) and could overlook 100,000 square miles per hour (or an astonishing 72 square kilometres per second). After 17,300 flights and an unknown number of images taken, it was retired in favour of increased satellite coverage and the deployment of Unmanned Aerial Vehicles (UAVS).

The look of these clandestinely obtained images, in turn, influenced the aesthetics of artists working from the air, as we discuss in the next chapter.

The Soviet launch of the first of 41 Sputnik satellites in 1957 transformed the landscape of aerial reconnaissance, although the first satellite was little more than a radio transmitter. The beachball-sized package circled the Earth for 28 days at an orbit ten times higher than even the Blackbird could fly. No longer was atmospheric flight the highest platform from which to observe the world below. Outer space begins approximately 100 km (62 miles) above mean sea level, the boundary beyond which an object must exceed orbital velocity to get higher. At present, only rocket engines are capable of such a feat. The Americans responded within months of the Russian success with the launch of *Explorer 1*, and in 1959 transmitted back to Earth from *Explorer VI* smudged TV images that constituted the first pictures of Earth from space. That same year the Central Intelligence Agency launched the *Keyhole-1* spy satellite, which took pictures with a ground resolution of 12 metres (40 feet) (illus. 48). Since then, the advance in clarity of

48 Vertical view of a tiger bush plateau in Niger. Satellite image from the declassified Corona KH-4A national intelligence reconnaissance system, 31 December 1965.

earth surface imaging has been rapid: a current estimate of capabilities of the most recent satellite in the series, *Keyhole-12*, which in essence is a Hubble telescope aimed downward, is a ground resolution of 10 cm (3–4 inches), while the best satellite images available to civilians have a resolution of around one metre.

Ground resolution is a measure of geographical detail and accuracy, but duration and frequency of observation are also important. The American National Aeronautics and Space Administration agency (NASA), created to respond to the Soviet space programme, began in 1960 to put up a series of weather and earth observation satellites, starting with *Tiros 1*. By 1964 weather satellites were completing global coverage every 24 hours. Unlike aerial photography, which was focused on more permanent

73

surface features – topography, geology, vegetation and settlement – weather satellites produced images of atmospheric phenomena: cloud and circulation patterns as well as surface temperatures on land and water, measured by infrared reflexivity (illus. 49). Today, two kinds of weather satellites circle the globe and provide continuous coverage of almost the entire planet. Geosynchronous craft are positioned to maintain a stationary position above the equator at 35,880 km (22,300 miles), and cover an entire hemisphere with instruments imaging in both visible and infrared parts of the spectrum. Polar satellites orbit at only 850 km (530 miles) above the Earth and fly longitudinally. The United States, Europe, Russia, China and India all have weather satellites in orbit. The continuous stream of data they provide is rendered into graphic form in the highly coloured weather maps we have grown familiar with, and animated by time-lapse technology (illus. 50). Both still and real-time images of Earth's surface are readily available today through the Internet on a home computer. The US Department of Defense has its own dedicated meteorological satellite, the only one known to be able to provide images in the visible spectrum of the Earth at night.

49 ESSA 3 Satellite, launched 2 October 1966.

While NASA was able to begin systematic imaging of the atmosphere in the mid-1960s, it was 1972 before the agency began a similar programme for ground coverage. The stimulus for a terrestrial imaging programme came from the US Geological Survey (USGS), the American agency responsible for national topographic mapping. The director of the USGS had seen photographs taken by astronauts in the Mercury and Gemini programmes in the 1960s and recognized the value of images from space for his agency's work. But military authorities objected that their own secret reconnaissance would be compromised; in addition, NASA's commitment had been focused wholly on lunar and space studies, and there were concerns about the value of such information in relation to costs. Once these objections had been overcome, NASA began collecting continuous and consistent information about the Earth's resources, using satellites that sent back medium-resolution digital photographs of the surface. There have been a total of seven Landsats launched, and the first one alone, which operated until 1978, acquired more than 300,000 images with its Multi-spectral Scanner. As of 2007, the programme had

50 Weather satellite system, 19 October 2005.

74

51 The Aral Sea on 4 June 1977, 7 September 1989 and 27 May 2006. Landsat image.

logged in more than two million images, taking approximately 400 per day, allowing continuous monitoring of surface resources and land uses. The French SPOT system was developed as an alternative, European satellite monitoring system of earth resources and offers surface images of similar quality. Launched initially in 1986, there have been five satellites offering images in both black-and-white and colour at a resolution of 2.5 metres (illus. 51).

The USGS, however, could not rely solely upon satellite images for mapping purposes, which demanded precisely consistent aerial photographs at a higher resolution and without cloud cover in order to update its topographical maps. In 1980 it started the National High Altitude Photography programme to document the contiguous 48 states in

black-and-white from 12,190 metres (40,000 ft) every five to seven years, each image covering a little more than five square miles. In 1987 the programme was renamed the National Aerial Photography Program, Hawaii was added, the altitude was halved to 20,000 feet and the USGS began acquiring photos in both black-and-white and colour infrared, using nine-inch film. Films are shot along north–south traverses keyed to 7.5-minute quadrangles (illus. 52). Each nine-inch photograph covers a quarter quadrangle and there are strict specifications regarding sun

52 San Diego, 30 September 1996, NAPP.

angle, cloud cover, minimal haze, stereoscopic coverage and image inspection. The current USGS archive comprises over 10,000 rolls of cartographic quality aerial photography, to which some 700 are added each year, allowing detailed historical interpretation as well as geographical examination.

As computers moved out of government laboratories and military facilities and into homes and private offices, mapping software companies added programs available to civilians. Keyhole, Inc. – named after the satellites and funded in part with venture capital funds from the CIA – developed a geospatial application that used digital remote sensing data called Earth Viewer. In 2004 Google bought the company and the following year launched what is now the most widespread aerial viewing mechanism currently available, Google Earth. Essentially a user-friendly Geographical Information System – that is, a computer and software system able to manipulate locationally coordinated data from different sources and present them in various graphic formats to allow web-based mapping – Google Earth offers the viewer the conceit of flying over the earth at altitudes ranging from outer space (nearly 16,000 miles) down to less than 100 feet. Their viewer has a resolution of at least 15 metres for most land areas, although in some cities such as Las Vegas, Nevada, it is as high as 15 cm (6 inches). The system moves seamlessly in scale from digital satellite images at the higher altitudes to aerial photographs for lower levels, and allows a wide variety of overlays providing locational information, as well as being increasingly tied into ground photography of cities such as Los Angeles. The site has raised concern among some critics over privacy and intrusion, criticisms that have been voiced since the early days of aerial photography. In response, high-resolution images are deliberately at least three years old, and although individual cars can be distinguished, licence plates remain unreadable. The popularity of the site has been great enough to produce physical changes on the ground. In 2007 the view of a United States Navy building on Coronado Island in San Diego, constructed in the 1950s, was modified by vegetation planting at a cost of $600,000 when its ground plan was shown from Google Earth images to take the form of a swastika (illus. 53). Some citizens in the United Arab Emirates have expressed indignation on seeing through

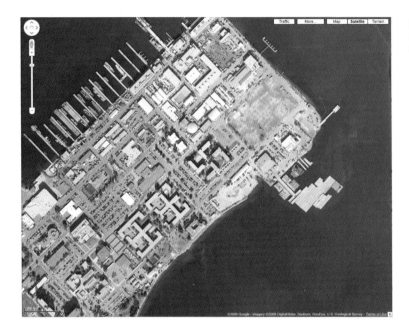

53 Google map image of the Naval Amphibious Base, Coronado, San Diego, showing the swastika shaped building.

the site the disproportionate areas of land occupied by royal residences as opposed to the crowded quarters of ordinary citizens, while in many cities business and individuals have modified their roofs to become more aesthetically pleasing from above, just as companies near airfields used their roofs as advertising signs in the early days of flight. In 2004 the US Undersecretary for Intelligence in the Department of Defense announced a programme to provide the American military with continuous real-time coverage of most of the Earth from aerial surveillance. These would be available to its personnel over a secure 'war net', yet to be developed, essentially a more powerful version of Google Earth, combining maps, aerial photographs and computerized information from a GIS.

As with Google Earth, aerial photographs play a significant role in Geographic Information Systems (GIS), which have allowed their long-standing close relationship with topographic and thematic maps to be further enhanced. This technology allows one, for example, to scan a topographical map into a GIS, and incorporate the data collected on pollen distribution through air samples over the same area, then superimpose

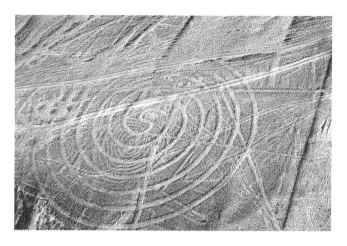

54 Nazca, Peru, spiral drawn across the desert plain.

both over an aerial photograph, selecting and removing elements to produce a satisfactory image. Repeated over the course of a year, and adding such information as wind direction and speed, the results can be animated to allow predictions of which households are most likely to suffer most from allergies under different weather conditions. Another example might be to correlate relevant data points for archaeological sites on aerial photographs in order to predict sites for digging (or to select where to aim a satellite-based ground-penetrating radar at the indicated sites to see what might lie below the surface). Large-scale earth-moving equipment used for mining or levelling construction sites now rely heavily on aerial topographic survey: 'robodozing' has replaced the white sticks and theodolites of the surveyor with remote sensors in the bulldozer's cabin linking satellite data directly to the machine's blade. All these activities rely heavily on GPS coordinates.

GIS evolved before the GPS system was put in place, an early example being the Canadian Department of Agriculture's use of a computer-based system in 1962 to correlate different data on land usage in rural parts of the country. NASA established the Earth Observing System (EOS) in 1999, coordinating data from satellites, weather balloons and ground-based sensors to compile information on environmental factors such as air temperature, humidity and aerosol concentrations from the ground up through to the stratosphere. The system was generating so much data – terabytes per day – that NASA computers were overwhelmed and analysts simply dumped the information onto storage discs. They were unable to work out how to even organize the data until Google Earth was established; now they superimpose it on 3D global maps in what is called iEarth, allowing a user for the first time to pull up a fully integrated, multi-instrumented image of almost any place on the planet.

The move towards a totalizing bird's-eye view of the world that began with imaginative maps and became instrumented with the technologies

79

55 Satellite view of a tropical storm in the Caribbean.

of camera and flight continues at an ever more rapid pace. Pictometry – a small company located in Rochester, not far from where the US Army established its first aerial reconnaissance school – is currently creating the most detailed aerial views of cities ever made. The company sends out dozens of Cessna light aircraft that fly grids over major cities, creating digital photographs of every square metre from all directions, including at a low, oblique, 40-degree angle from the ground. The images are then stitched together and made available on a program that allows the viewer to zoom in and fly around individual buildings. Beyond the thrill of virtual flight and observation at hitherto inaccessible angles, tax agencies, law enforcement and public safety personnel find the service invaluable. The use of Unmanned Aerial Vehicles (UAV), such as the Global Hawk, will eventually extend many of these technologies into real-time availability. These vehicles can fly from the West Coast of America to Australia, for example, at altitudes of up to 19,812 metres (65,000 feet), remaining aloft for up to 24 hours and covering an area of 137,000 square km (53,000 square miles). The UAV carries radar, electronic and optical sensors that

56 John Glenn's photographs of Earth from the Mercury 6 mission, 20 February 1962.

can penetrate clouds and dust and operate at night. While the military uses of such technology are obvious, the gains for environmental science as well as commercial exploitation of earth resources are considerable.

The Camera in Space

The most obvious and significant developments in obtaining and recording the aerial view of earth have been the replacement of film with various forms of digital sensing devices and the replacement of the human eye-witness with mechanical instruments. Yet the camera and the human eyewitness retain a powerful hold on the imagination, and command an authority that is difficult for the purely mechanical image to challenge. An early and surprising example comes from 1962, when John Glenn became the first American to orbit the Earth. NASA had resisted the idea that the astronaut should take photographs from the *Mercury* capsule. They were worried it would interfere with his flying, and that it added weight to an already finely calibrated capsule load for a task considered irrelevant to the mission's science goals. Glenn, displaying the kind of initiative characteristic of earlier aviation pioneers, went to a drugstore, purchased an inexpensive 35 mm rangefinder, and had it adapted so he could operate it wearing his pressure suit and clumsy gloves. His dramatic snapshots were widely reproduced and so popular that they convinced NASA to provide each future astronaut with a personal camera (illus. 56). Over the course of the following 30 years American astronauts took 268,000 photos from orbit, and their Soviet counterparts produced a similar archive. Book collections of these images have sold well, and the website hosted by NASA has been a significant public relations tool in the agency's relations with the public and in lobbying the US Congress for appropriations.

Among the most dramatic and widely reproduced space photographs are those taken during the Apollo lunar programme that lasted from 1961 to 1975. Each of the seventeen Apollo missions included a highly detailed photographic programme that included still images taken with modified Hasselblad cameras. These Swedish instruments, originally developed

81

57 Michael Light, photograph from the book *Full Moon* of *Intrepid* lunar module above the moon before descent, from a transparency by Richard Gordon, 14–24 November 1969.

58 'Pale Blue Dot' image of Earth from Voyager 1, 1990.

from captured German air reconnaissance cameras, were selected by NASA because of their interchangeable lenses and magazines and because of the quality of the images offered by their 6 x 6 cm roll film. The vast archive of photographs from the programme is now available on the web. It includes spectacular aerial photographs of the Moon's surface from different altitudes, many of which were re-mastered in the 1990s by the artist Michael Light for his exhibition, *Full Moon*, mounted in cities around the world (illus. 57).

Still photography aboard the Apollo spacecraft was very tightly planned – weight considerations made for severe limitations on the numbers of rolls of film that could be carried. The focus on the Moon, astronomical phenomena and the space vehicles and equipment them-selves reflected the scientific pretensions and practical demands of the missions. Yet the best-remembered and most impactful photographs that we have inherited from the Apollo missions were not initially given any priority, nor were they of planned photographic targets. These are photographs of the Earth taken from sufficiently far away to reveal the round globe floating as a planet in space. The most distant aerial view of Earth would be taken mechanically in 1990 by the *Voyager* spacecraft from more than 6.4 billion km (4 billion miles) distance, the 'Pale Blue Dot' image in which our planet is very nearly invisible and certainly indistinguishable among the stars (illus. 58). But the two best-known, and perhaps best-loved, views of the planet from space were taken with hand-held 70mm Hasselblads by astronauts during the Apollo missions, and they were what NASA had deemed 'targets of opportunity', or objects of interest selected by the astronauts themselves. 'Earthrise' is the name given to a photograph taken by Bill Anders from *Apollo 8* in 1968, the first flight to orbit the Moon, and thus the first to permit humans to witness for themselves the phenomenon of Earth rising over the lunar surface. Seeing the blue and white globe juxtaposed with the sterile grey surface of the Moon inverted a familiar and romantic nocturnal image, opening up a new perspective on the planet's relations with other worlds (illus. 59). The poet Archibald MacLeish, who in 1943 had written optimistically of the 'airman's view' as a new vision of earth, penned a widely syndicated op-ed piece for the *New York Times* on Christmas Day 1968, claiming that

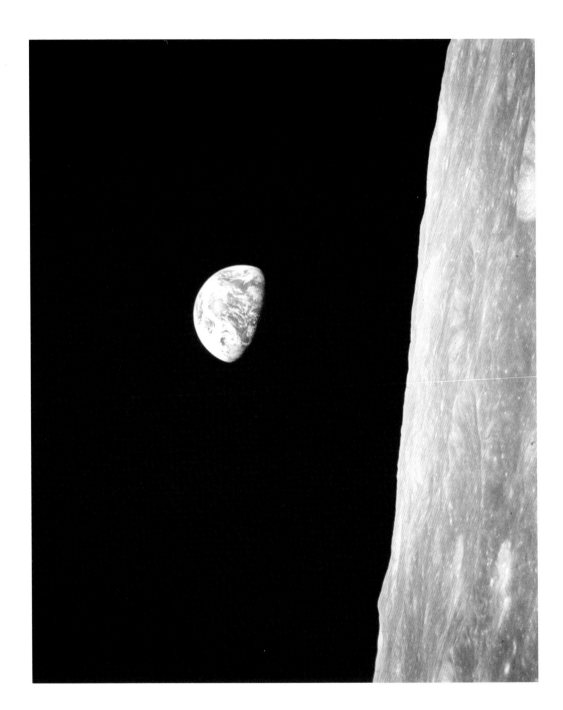

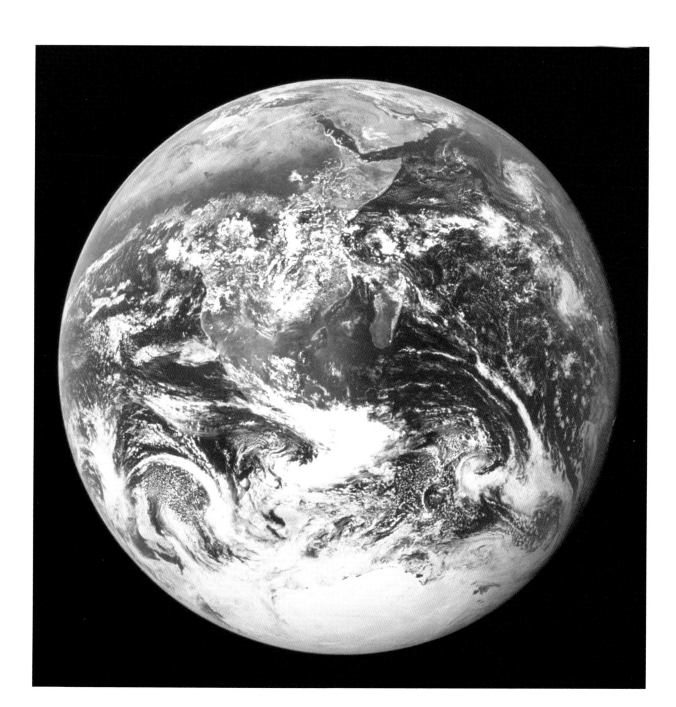

this photograph represented a 'Copernican moment' in which humans for the first time saw themselves as 'Riders on the Earth', forced to recognize the spatial and environmental limitations imposed by their 'home planet'.

The 'Earthrise' photograph was followed four years later by another, even more dramatic picture of the globe. On the outbound leg of the final *Apollo 17* mission to land on the Moon, the crew captured a spectacular series of images of the un-shadowed Earth. Although there had been some planning in terms of the distance from Earth and the time and angle at which this photograph would best be taken, when you consider the speed that the 'terminator' or shadow of night passes over the planet, the tiny capsule with steamed windows from which it was taken and the fact that astronauts shot photographs from the hip, it is a spectacular achievement (see illus. 60). AS17-22727, to use the NASA number allocated to the image, or 'The Blue Marble', to give it its more popular name, has become perhaps the most widely reproduced photograph in human history. A portrait of the planet from 45,000 km (28,000 miles), it has become the definitive God's-eye view, in part because we are aware that a human witness was behind the camera and a human finger operated the shutter. No human has since been higher than the orbit of the International Space Station, which hovers a mere 354 km (220 miles) above the Earth, far too close to capture the planet in a single frame. In the *Apollo 17* photograph the Earth sits centre frame, dominated by the blue of the oceans and the white of cloud and Antarctic snow, with the continent of Africa dominating the land-masses. The Arabian Peninsula is clearly demarcated and parts of the Australasian archipelago are also just visible. The latitudinal bands of climate are apparent in the varying land colours and the streams of cloud that circle the earth form a continuous stipple along the Equator, and a band of sickle shapes indicating the westerly storm systems moving over the southern mid-latitudes. This colour combination, the thin shroud of atmosphere and the watery quality of the picture give it an intense, almost mystical, quality and indeed it has become a powerful icon for the global environmental movement, even though it is often reproduced with South at the top, or even wholly inverted.

Previous pages:
(left) 59 'Earthrise' from *Apollo 8*, 1968.

(right) 60 'Blue Marble'/Image of Earth from *Apollo 17*, 1972.

Popular Air Photography

If the human ability to imagine the world from above is a hardwired cognitive skill stemming from manipulating our bodily environment at different scales, then our aerial view of the world has been equally shaped by the history of photography from aircraft and satellites. Since the 1970s the aerial perspective seems to have become closely bound to environmental concerns, so that not only is the technology of aerial photography and remote sensing a principal source of data for environmental monitoring and modelling of such phenomena as climate change, ice melting, vegetation loss and species extinction, but, in the popular imagination, aerial images of the earth's surface and landscapes have come to be framed almost exclusively through an environmentalist lens.

A major proponent of the aerial view and its deployment as a visual rhetoric in the environmental movement is the National Geographic Society, a non-profit organization founded in 1888 that from the 1920s onward has been a prominent sponsor of photographic expeditions, including Richard Byrd's first flight over the South Pole in 1929. His expedition took aerial photographs of approximately 60,000 square miles of the continent, the largest amount of newly discovered land photographed from the air at the time. The following year Melville Bell Grosvenor, son of the Society's president and later editor of its magazine, made and published the first natural-colour aerial photographs (see illus. 62). In 1941 the society made its extensive and unique archives available to the American military, including its aerial photographs, which were considered a valuable strategic resource.

Among the aerial photographers sponsored by the National Geographic Society was Bradford Washburn, a young climber and geologist from Harvard who had been making aerial photographs of mountains since 1928. Washburn taught at Harvard's Institute of

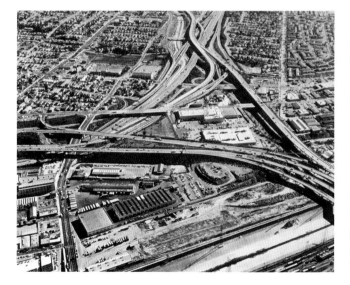

61 California freeways: Santa Ana, Pomona, and the Golden State, 1956.

Geographical Exploration from 1935 until 1942, and in 1936 became the director of what would become the Boston Museum of Science. While teaching, he inherited a 53-pound Fairchild aerial camera from Captain Albert William Stevens, the balloonist who in 1930 took the first photograph showing the curvature of the Earth. Stevens taught Washburn how to use the large-format roll camera, and the younger man used it to make what are still the most detailed aerial portraits of mountains and glaciers in Alaska and the Yukon. Climbers today routinely use his black-and-white images to plan ascents, but the images are also exhibited in art galleries and museums, and were published in the magazine *National Geographic*.

Washburn personified the society's editorial aesthetic, which was increasingly defined, in part, by the use of oblique aerial images as the paragon of geographical veracity. *National Geographic* is published in 32 languages and read by an estimated 50 million people each month; its covers are often aerial photographs, and remotely sensed images are now an integral part of the publication's graphic toolkit. The height of aspiration for amateur photographers for decades has been to take pictures of the quality used by the magazine, including those made from

62 The first successful aerial colour photograph used the Finaly process: the Statue of Liberty National Monument, New York, a *National Geographic* cover in 1930.

88

63 Bradford Washburn, *Windstorm*, Mount McKinley, 1942.

the air. As the magazine's concerns have evolved over time to broaden from exploration and conservation into environmental research, so the tastes of the public have followed. Thus the blanketing of the planet with remote sensors that come ever closer to providing continuous, real-time coverage from above has not replaced photography made from the air. Quite the opposite: familiarity with aerial imagery through magazines and programs such as Google Earth seems to have stimulated the demand for other aerial imagery. In fact, Yann Arthus-Bertrand's aerial photos have often appeared in *National Geographic*.

89

Born in 1946, Arthus-Bertrand ran a game reserve in France before moving to Kenya in 1976 to study African wildlife. To support his research, he sold balloon tours to tourists, becoming convinced that seeing the world from above was the most powerful environmental education tool. His millennial photography exhibition, *Earth from the Air*, was the product of five years and 3,000 flying hours, shooting 15,000 rolls of film. From a stock of 100,000 images he curated both show and book, the latter consisting of 195 photos taken over 75 countries and every continent, including the Antarctic. His vertical and oblique images,

64 Uluru or Ayers Rock in Australia's Northern Territory.

reproduced in high-definition with intense colour, have an immediate aesthetic appeal. Most of the photographs were taken from a helicopter with the door off during two-hour-long sessions at daybreak and during the 'golden hour' before sunset, when light angles offer the most dramatic contrasts and most saturated colour. Arthus-Bertrand and his team of fifteen assistants often scout locations beforehand and are not shy about posing people in the pictures. He uses GPS to keep track of his vantage points, shoots through a polarizing filter to cut down on glare and operates a variety of cameras in 35mm and medium formats. His book *The Earth from the Air: 365 Days* has sold more than 2.5 million copies. Its 'eye-candy' images are juxtaposed with what has become a predictable message about humans' negative impacts on the Earth and the need for 'sustainability'.

Arthus-Bertrand has claimed that he is not an artist, nor one who transforms reality, but a photographer who seeks to capture and record the world as it is, or at least as we perceive it. Much the same could be said of Robert Cameron, whose first camera was a Kodak Brownie given him in 1919. He worked during World War II as a civilian taking both ground-based and aerial photographs for the US War Department, but it wasn't until 1969 that he published the first of his seventeen *Above* . . . books, starting with his home city of San Francisco. Although he has

90

worked over Yosemite and Hawaii, Paris and London, he is best known for his photographic books of large American cities such as New York, Los Angeles, Chicago and Las Vegas. These images, too, are intended to emphasize dramatic, eye-catching scenes of iconic places and structures, and are photographed in sharp light and glamorous colour. They are not intended to be analytic, and his series has sold a total of 2.5 million copies. Although he has photographed from a variety of aircraft, he prefers to use a medium-format Pentax with its gyrostabilizer from a helicopter and works characteristically from about 1,000 feet (305 metres). Like Arthus-Bertrand, he includes both vertical and oblique shots, but

65 Yann Arthus-Bertrand, Village in the heart of rice fields near Antananarivo, Madagascar.

66 Houses in Souk El Oued, Algeria.

Cameron seems to prefer oblique shots providing a long landscape impression and geographical context, while the Frenchman favours pattern in the landscape, produced from a more vertical angle.

An extension of popular aerial photography is the appearance of handbooks intended for use by air travellers wishing to recognize the ground over which they are flying. Two of these appeared early in the twenty-first century, taking advantage of the fact that 10.5 million domestic and international flights now pass over the United States alone every year. The total number of commercial air passengers worldwide in 2006 was estimated at 4.4 billion by the Airports Council International. The Boeing 737, which carries 180 seats on average, is the most widely used commercial aircraft, with 6,000 delivered by April 2009 and another 2,200 on order. According to the company, a Boeing 737 lands somewhere on the globe every five seconds. Given that up to as many as a quarter of these passengers may be sitting next to a window, it would seem such books have a large potential market. *Window Seat: Reading the Landscape from the Air* (2004) and its sequel *Window Seat: Europe* (2006) by Gregory Dicum use aerial photography to teach people landscape interpretation from 35,000 feet (10.7 km). Dicum, who learned aerial-photo interpretation while attending Yale University's School of Forestry and Environmental Studies, believes that time in the air should not be wasted, that it is a unique opportunity for the general public to educate itself about the world. In fact, most of the aerial images he reproduces in the book are satellite and high-altitude aerial images derived from government agencies.

67 Bird's-eye view of a swimming pool.

The same year as the second of Dicum's books appeared, another book about seeing the world from a commercial airliner was published. *Window Seat: The Art of Digital Photography and Creative Thinking* by Julieanne Kost is marketed as a self-help book for people seeking a creative outlet, especially during long flights. Kost, who spends much of her own time flying from city to city as a Photoshop instructor for Adobe Systems, holds degrees in psychology and photography. She found herself needing a way to continue fine art photography while teaching digital techniques, and realized that the view out of her plane window offered unique possibilities. The book consists of a manifesto for creativity, a portfolio selected from 3,000 images made during five years, and a helpful technical section about both film and digital aerial work. Unlike many contemporary aerial photographers, Kost often includes the wing or engine nacelle in her frame, and is open about

68 Barringer Meteorite Crater near Winslow, Arizona, a feature often seen by passengers during transcontinental jetliner flights.

69 Winter in Chicago metro area.

70 Parking lot, northern California.

71 Rape seed field.

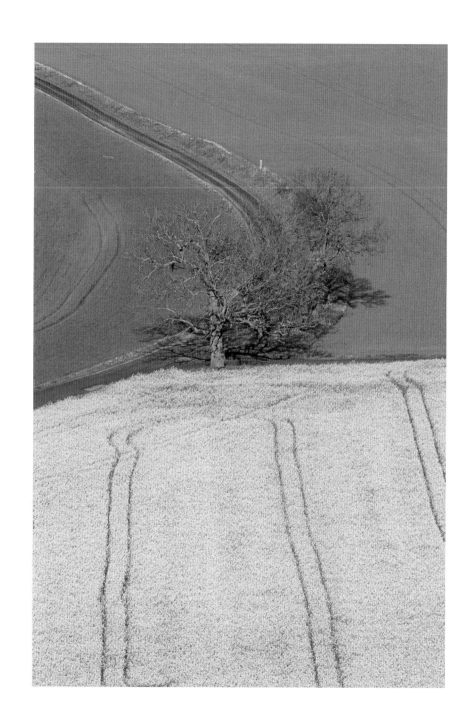

72 Field pattern.

using not only lens filters but also digital tools to clean up and enhance her ground images. She is also one of those rare artists who will photograph the atmosphere as well as the ground, showing how clouds interact with not just terrain but also with each other and light. Her aerial photography is aimed at creative and artistic outcomes, and thus has no overt tie to mapmaking or remote sensing objectives, such as environmental analysis or polemics. Her work thus points toward those artistic aspects of aerial photography that developed early in the evolution of the medium, but which have largely been subordinated to the instrumental uses of aerial photography. It is on this dimension that we focus our final chapter.

five

Aerial Photography as Art

We have already seen that the debate over the artistic potential of aerial photography began in the early years of flight, most notably among Italian Futurists. As with photography more generally, neither the airborne camera nor the images it recorded lent themselves to being placed within the hierarchical conventions that, despite the challenges of avant-garde artists, continued to dominate art practices and criticism in the early twentieth century. But despite their reservations, the Italians were among many artists who recognized that powered flight radically challenged conventional modes of seeing and experiencing space, and offered wholly new perspectives on familiar objects, revealing forms and patterns impossible to see from the ground. Inevitably, the creative potential of aerial photography soon attracted artists, and today there is a distinct genre of art that uses the air photograph as its medium.

Vision is based on boundary contrast: the eye's ability to distinguish light and dark and the spectrum of colour between red and violet, and to recognize recurrent forms. Everything we see is built up of no more than 24 basic shapes defined by these boundaries, ranging from closed circles and squares through polygons, and then into open figures such as right angles. The eye accords highest priority to the recognition of these features in repetition, particularly when they are symmetrical, using this capacity to distinguish everything from facial features through to potential habitats. Humans are, in short, pattern-fixated, and take great aesthetic pleasure from discerning pattern, seeing it stretched and broken and reformed. While the biological study of vision as pattern recognition suggests that it may be related to survival needs, within

the history of art the interest has been in how these patterns work compositionally in picture making, and it was in the very years that the camera was first mounted on aeroplanes that Modernist artists began to create images that sought to foreground shape and pattern over the conventional forms of figurative representation. In later life, the post-Impressionist Paul Cézanne became fascinated by such geometrical forms as cones, spheres and cylinders, and the Cubist painters Pablo Picasso and Georges Braque experimented with images in which surface pattern dominated over conventional perspective depth, seeking to deconstruct the 'conventional' artistic vision and ways of representing objects in space. While it would be wrong to claim that the aerial view – and especially aerial photography – generated Cubism, we have already remarked on the fascination that these artists had with powered flight and the new ways of seeing that it offered.

One of the things that aerial photography does remarkably well is to reveal and even create pattern at varying scales on the earth's surface. Unless viewed stereoscopically or taken from an oblique angle in sharp shadow, it also flattens the image, emphasizing surface. When aerial photographers deliberately seek out, frame and create pattern rather than seeing their work as serving purely documentary purposes, they approach the conventional realms of art. As both photography and flight have evolved into a wider spectrum of technology and become aerial and remote sensed imaging, so artists in the late twentieth and early twenty-first centuries have constantly broadened their definition of aerial art, suggesting that our understanding of patterns and their meanings is likewise expanding.

Obviously, the aerial photographer can concentrate on creating images that seek to satisfy conventional aesthetic concerns: capturing sublime images such as a volcanic crater, high mountain peaks seen from above or dramatic views of a coastline; artists can make picturesque images of rolling cornfields in late summer, or conventionally beautiful images of the patterns created by nature itself or by human activity, such as the striated lines of sand dunes or hillside terraces in the Alps or on Java. Such work is conventional and very popular, as the success of Arthus-Bertrand reveals. But the most memorable artworks in aerial

photography recognize that the medium offers far greater creative opportunities than the picturesque conventions of representing natural and human landscapes. Reflecting the Modernist and avant-garde context in which it developed, aerial photographic art has been dominated by an interest either in abstract patterns or in documenting human interactions with the natural world, with an emphasis – in recent years – on environmental criticism.

The complexity and beauty of form and pattern in natural and human landscapes – often a product of the interaction between these two shapers of the earth's surface – is apparent from the air in ways unavailable from the ground, and only partially paralleled in the topographic map. In the early years of the last century, both the French geographer Jean Brunhes and the British geographer Sir Halford Mackinder advocated a systematic practice of study based on direct observation of those physical and human processes that shape landscapes, to be documented through both maps and photographs. In the third edition of his *La Géographie Humaine*, published in 1925, Bruhne included aerial photographs, and he was a major influence in the formation of the First Congress on Aerial Geography held in Paris in 1938. The group proposed that the airplane become a mobile observatory for geographers, but it wasn't until after World War II that the French geographers were able to commission Emmanuel de Martonne to write a handbook on the use of aerial photography for geographical study. In Britain the Bristol geographer F. Walker published a similar text in 1953. De Martonne's handbook, along with other aerial photo books and reports that he knew from his time in Europe, profoundly influenced the American landscape critic J. B. Jackson, whose magazine *Landscape* and collections of essays celebrating and interpreting ordinary American landscape during the 1950s and '60s in turn shaped the perspective of a generation of photographers working in the air. Jackson himself, whose own fieldwork was conducted from the seat of a Harley-Davidson motorcycle, promoted the appreciation of farming scenes, small towns, highway strips and associated vernacular architectures. Jackson's contemporary, the British landscape architect Geoffrey Jellicoe, focused on more formal design traditions in cultural landscape, and

made significant use of aerial photographs in surveys such as *The Land-scape of Civilization* (1965). Like Jackson, he took a nuanced and layered approach to understanding and representing landscape impacts, a per-spective later subordinated to environmentalist fervour among many subsequent landscape photographers.

73 San Jacinto Monument from a helicopter in 1952 by Margaret Bourke-White.

Land and Environment in Aerial Photographic Art

Margaret Bourke-White, initially an architectural photographer, undertook her aerial work mostly on assignment for magazines. But her training as an artist at the Clarence H. White School of Photography is apparent in her journalistic images, and her photographs today command high prices as artworks. The images she produced in the 1950s while suspended in a harness from a helicopter over San Francisco Bay are as much about capturing aesthetic moments as documenting the geography of the area (illus. 73). William Garnett also trained at art school, and having achieved initial recognition for his Lakewood work, which was clearly influenced by abstraction, went on to produce tightly framed photos – mostly devoid of people – that revealed the abstract forms created by wind and water, farming and urban development. Some referred to him as the Ansel Adams of the air. Indeed it is difficult to distinguish the goals of Garnett's work from that of the best-known California Modernist photographer, Edward Weston, co-founder of Group f/64, whose 'straight photography' consciously sought to define a distinctly photographic aesthetic as determined by the technical capacities of the camera. Georg Gerster, although prominent for his photos of archaeological sites and ruins from the air, also undertook landscape work in colour that seemed to parallel Garnett's in its abstraction and attention to highly excerpted detail (see illus. 74). All of these pho-tographers sought in their aerial photography to transcend journalistic or documentary goals in order to capture their own version of what Henri Cartier-Bresson called 'the decisive moment': a concatenation of circumstances captured by the photographer that went beyond the specific time and place of an event. Cartier-Bresson believed that such

magical moments were disclosed only to those with a prepared eye, and captured only with a high degree of technical skill and understanding of the photographic medium.

Ansel Adams once commented that when Garnett was piloting his plane, he was literally flying the camera, and Garnett himself pointed out that the delay in circling the plane around to gain the same vantage point often meant that light conditions had subtly altered and the image was transformed. Taking photographs from an aeroplane as it passes over terrain is very different from helicopter work, where the platform can hover over the ground, making minor adjustments in direction, height and camera angle until the exact image comes into view. This can produce sharper but often less gentle images than those taken *en passant*, and this is especially true for obliques. Aerial photography has always been subject to unique spatial and temporal demands, and in Adams's opinion Garnett, as both an accomplished pilot and a brilliant photographer, was well prepared to recognize and capture the decisive moments. The history of twentieth-century photography involved challenges to that belief, and aerial work was not immune. While some artists sought to use photography as a technology for recording reality, and thus adhered to strict limitations on how they would allow themselves to manipulate their negatives in the darkroom, others would consider a negative as a starting point from which to crop or enlarge an image, enhance its contrast or colours, or even draw on it with various other media. The shift from a chemical-based negative to a digital computer file would only heighten the debate.

Emil Schulthess, art director for the airline Swissair, became perhaps the pre-eminent aerial photographer of the mid-twentieth century. He employed oblique angles more often than the verticals of Garnett and Gerster, so his work tended to be less abstract. Appropriately for a nation with a strong tradition of dramatic and innovative topographical maps that capture with dramatic relief shading the forms of its mountain landscape, Schulthess produced *Swiss Panorama* in 1982, using a unique device to suspend his camera below a helicopter and rotating it to produce 360° images. Culture is as significant as nature in his work, and he admitted the human presence more freely than most American aerial photographers.

74 Earth Art, Ohio, photographed by Georg Gerster, 1981.

His books on Russia, Africa and the Antarctic were by no means straight-forward documents of national or geographic identity, but inquiries into the reciprocal shaping of lands and peoples. Schulthess took the first coloured aerial photograph of the South Pole in 1957, during the world-wide scientific effort known as the International Geophysical Year. He then superimposed on the print a graphic of longitudinal lines radiating outward from the geographical pole near the small collection of Quonset huts at the Amundsen-Scott Station, and labelled them with the degree intervals, using a red line to denote the Prime Meridian, stretching away towards the Greenwich Observatory in London (illus. 75). He thus admits the limitation of the unaltered photographic image to make sense of such an isotropic environment, superimposes a graphic device to augment the representation of the icescape, and at the same time neatly foregrounds our anthropocentrism.

75 Emil Schulthess, *The exact geographic position of the South Pole, near the Admundsen-Scott Station*, 1958.

106

76 Crop circles in Slovenia.

Likewise, Mario Giacomelli, a painter who in the mid-1950s began to photograph his native northern Italian region, was not satisfied to simply document what he called 'the metamorphosis of the land' by farmers. In 1970 he started to photograph Semigallia from the air, then began to plow the actual fields themselves to create the patterns he desired. He, too, drew directly on his negatives by scratching the emulsion to further enhance the patterns.

Henri Cartier-Bresson would have been scandalized by such interferences with the taken image. But Schulthess wasn't satisfied with simply recording a historically important photograph; he sought to treat it as a piece of conceptual art, drawing on it by hand and linking it to the history of science, exploration and timekeeping, thus encouraging the viewer to make meaning out of the emptiest viewscape on the planet. Making

the artist's intervention visible by literally drawing attention to the arte-factual nature of his photograph was a decidedly self-aware, Modernist gesture. The prominence of Schulthess and Giacomelli as aerial-photo-graphic artists stems from their determination to reach beyond not only documentation, but the limitations of the medium itself.

In 1976 Marilyn Bridges flew over the Nazca Lines in Peru and became a convert to the aerial perspective. She had worked as a travel photographer, and initially hired the plane to illustrate a story about these cultural phenomena. The enormous geoglyphs representing

77 Mario Giacomelli, *Paesaggio 408*, 1970s.

different animals and birds, which cover 500 square km (200 square miles), were inscribed over nearly a millennium, between 200 BC and around AD 700, by people sweeping aside the dark oxidized rocks on the desert surface to expose lighter ground underneath. The lines are visible on the ground, but the mythic figures and the geometrical patterns they create come into true focus only from at least several hundred, if not thousand, feet above the ground. They have inevitably provoked theories about their origin, ranging from ceremonial pathways to alien landing strips. The crew took off the aircraft's door, strapped Bridges into a seat with the pilot's belt and took off. The experience terrified Bridges, yet so exhilarated her that she reorientated her work from colour to black-and-white film, and entered the Rochester Institute of Technology as a fine art student to develop her creative skills, also taking courses in archaeology. There Bridges discovered two things: that she missed travelling to exotic locations, and that, despite its historical association with aerial photography, the school offered no courses in aerial work. Her instructor, the renowned landscape photographer John Pfahl, whose work was loosely connected to the American Land Artists who had inscribed large-scale patterns into desert landscapes during the previous decade, suggested that she undertake aerial work over Rochester itself. She contacted an industrial photographer who had served in aerial surveillance during World War II, and took lessons in how to use a medium-format camera at low altitudes, seeking to maintain in her images of the ground a balance between intimacy and distance. She typically flew at an altitude of only 300–500 feet (92–152 metres), usually at twilight, when shadows would give her subjects stronger definition. Although she became best known for her work over ruins and temples, from the Pyramids of Egypt to those of Central and South America, Bridges also photographed secular landscapes from above, and her work at times bears a strong stylistic resemblance to Garnett's and Gerster's (illus. 78). She continues to make a living as a commercial aerial photographer, but her artworks, silver gelatin prints painstakingly toned with selenium, have a depth and richness that not many aerial artists achieve.

Another artist who manifested a striking shift into aerial work is Emmet Gowin, who teaches photography at Princeton University. Known

78 Pyramid of Khephren, Giza, by photographer Marilyn Bridges, 1993.

early in his career for intimate family photographs taken with a large-format 8×10 lens on a 4×5 camera, Gowin was awarded a publicly funded commission to conduct a photographic survey of Washington State in 1980, shortly after the Mount St Helens volcanic eruption (illus. 80). Unable to secure permission to approach the mountain on the ground, he hired an airplane and worked with a medium-format handheld camera. He returned annually over the next six years to picture the devastation, on his final 1986 trip flying over and photographing the Hanford Nuclear Reservation in Washington State. That led him to work above mines, industrial facilities, corporate agricultural fields and military sites around the world, illustrating environmental devastation: from the battlefields of Kuwait to golf courses in Japan and petrochemical plants in the Czech Republic. Among his most notable series is that of craters at the Nevada Test Site. He is one of the few civilian photographers ever allowed to work over the secure area from the air (illus. 79).

Gowin works both in the vertical and the oblique, uses only black-and-white film, and hand-tones his prints with various minerals and colours. Unlike Garnett – who, ironically, sought beauty in both natural and cultural patterns but achieved recognition for capturing what many environmentalists regarded as the supreme ugliness of urban sprawl – Gowin systematically seeks out images of large-scale human destruction of nature. Ironically again, despite Gowin's ingenuous claim that 'when I look at the American landscape, I . . . feel with great sadness that we did this to ourselves', he creates uncommonly beautiful prints of sublimely ugly environmental depredations. While such dissonance became an almost predictable element in North American landscape photography during the late twentieth century – notably among artists such as Richard Misrach and Edward Burtynsky – Gowin was the first artist to take full advantage of it in aerial work.

A student of Gowin's who worked as his assistant over Mount St Helens is David Maisel, who has since photographed extensively in colour over the large mines and dry lake-beds of the American West. While both Gowin and Maisel share environmental concerns, Maisel has introduced an added level of formalism to his work, seeking to frame the startling toxic colours of evaporation ponds and bacterial blooms as abstractions, so that the

overleaf:
79 Emmet Gowin, *Subsidence Craters, Looking East from Area 8, Nevada Test Site*, 1996.

(right) 80 Emmet Gowin, *Mount St Helens Area, Washington*, 1980.

111

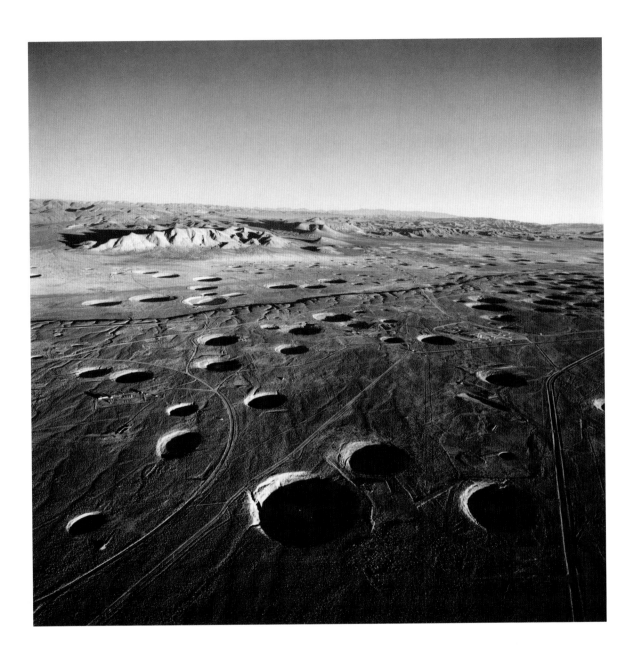

82 from 'Waste Land' by David T. Hansen,
from *Meditations on a Managed
Landscape*, 1985 6.

81 'The Lake Project 20' by David Maisel,
from *The Lake Project*, 2002 (Owens Lake,
California).

photographs focus more on composition than polemics (illus. 66). Like Richard Misrach's cloud photographs taken from low ground, and whose metal frames are stamped only with the date and terrestrial coordinates that locate them, Maisel's work at polluted sites remains deliberately untitled, lest viewers become fixated on the subject matter rather than the image itself, a strategy more commonly associated with abstract painting than documentary photography.

Unlike fine art photographer Maisel, who uses aerial means to create formal compositions out of polluted and industrial sites, David Hansen might best be described as an environmental photographer who uses aerial views. Hansen earned a Masters degree in Fine Arts from the Rhode Island School of Design and taught there from 1983 to 2000. He started documenting the coal mining industry and its effects, including power generating plants and transmission lines, revealing the reach of the industrial aesthetic as well as documenting chemical pollution of the landscape. His work over America's most toxic locations – the Superfund sites – documents notorious locations such as the Love Canal section of Niagara Falls and the Tooele Army Depot in Utah where old munitions are disposed of, but also sites that are kept virtually invisible to the public, such as asbestos mines (see illus. 82). It is telling that his book, *Waste Land: Meditations on a Ravaged Landscape*, was published by the Aperture Foundation, founded in 1952 by people prominent in both

83 Angkor Wat, Cambodia.

American photography and the preservation movement, notably Ansel Adams and the Newhalls. In his introduction Hansen makes explicit the theoretical connections between his aerial photography, military technologies and Western ways of seeing and understanding the world:

As my work evolved, the aerial view increasingly seemed to be the most appropriate form of representation for the late twentieth-century landscape: an abstracted and distanced technological

view of the earth, mirroring the military's applications of aerial photography for surveillance and targeting. The aerial view realizes the Cartesian rationalization and abstraction of space that has pre-occupied Western culture and visual art for the past 300 years. It delivers with military efficiency a contemporary version of the omniscient gaze of the panopticon, the nineteenth century's ultimate tool for surveillance and control.

Aerial Photography and Landscape Design

One of the more experimental meetings of aerial photography and art is the collaboration between photographer Alex MacLean and landscape architect James Corner. MacLean learned to fly in 1972 as an architecture student at Harvard, seeking to understand better the context of the built environment. His aerial experience helped convince him to broaden his studies into landscape architecture, and J. B. Jackson became one of his mentors. MacLean started his own aerial photography company in 1975, using a 35 mm camera on a gyroscopic stabilizer while piloting a Cessna aircraft. Initially, Maclean's aesthetic was formalist and abstract, similar to Garnett's, treating the patterns created by tractors in fields as if they were drawings and creating images of colour variations in cultivated fields that resemble Rothko canvases. But as he began to photograph clear cuts in forest lands and industrial pollution in water bodies or atmosphere, he became more interested in assembling typologies of land usage and density, in particular where borders and boundaries were apparent either within the frame of a single photograph or amongst discrete series. Starting in 1990, he and Corner began travelling around America, publishing a collection of aerial photographs with connected cartographic tracings and mapping collages, *Taking Measures Across the American Landscape*, which united landscape design with aerial photography in an entirely new fashion. Pattern and measure are revealed from the air as the shaping principles of the American landscape. American space is pictured as a great experiment in creating a human order across a continental space that prior to European colonization had been only

lightly inscribed by culture. From the air, intention and meaning become apparent in large-scale form and pattern.

During the same period MacLean worked with the historical geographer of American urban forms John Reps to replicate photographically the bird's-eye views of towns and cities in the Mississippi Basin that illustrated promotional county atlases in the nineteenth century. In yet another book, *Designs on the Land*, the grids of cities and agriculture are juxtaposed with ancient Native American ruins, parking lots in Houston with fleets of abandoned jet bombers, amusement parks with forests ravaged by clear-cutting, complicating the story of American landscape patterns and environmental impacts. As in the MacLean and Corner volume, this work catalogues shifting and overlapping patterns of land use over time, which themselves act as to document changing public policies and private interventions. Working alone,

84 *Edinburgh: the Castle, the Medieval Old Town and the Georgian New Town*, 1982, by Angus and Patricia Macdonald.

85 'Bunkers and Hay Bales', from *Disarming the Prairie* by Terry Evans, 1994–6.

118

MacLean has photographed from the air patterns of urban development in cities from Rome to Auckland. Currently, he is engaged in recording climate change, which in his view encompasses urban sprawl as one of its causes. Working along the Gulf Coast in the aftermath of Hurricane Katrina and over power plants and coal mines in the Ohio Valley or the West, MacLean photographs laterally into the atmosphere as well as obliquely to the ground, seeking not just to demonstrate surface causes and effects but also to show the impacts on the thin and fragile membrane of atmosphere.

In a less experimental vein, the Scottish couple Angus and Patricia Macdonald formed Aerographica, whose mission is environmental research, documenting and interpreting the history and present condition of natural and cultural landscapes. In addition to publishing five books, they maintain an archive of more than 150,000 aerial images of the British Isles, Western Europe and parts of North Africa. Both are pilots, and their work is shaped by Patricia's interests as an environmental photographer, and Angus's background as an architectural historian: it demonstrates

86 Terry Evans *Prairie Scrolls*, 1978 and 2007.

the application of an aerial aesthetic to a deeply historical, Old World landscape. The geology of Scotland in *Above Edinburgh and South-East Scotland*, for example, is powerfully evident as rocks poke through its relatively thin layers of soils, and, as Patrick Geddes's Outlook Tower sought to achieve a century ago, their aerial views show how agricultural and urban development have been profoundly shaped by those physical circumstances (see illus. 84). Layers of historical and contemporary built environment are conjoined and castles and abbeys are located within eyeshot of terraced houses and industrial yards, even as the architectural axes of earlier centuries are preserved.

Another artist who uses aerial photography to explore pattern and colour on the ground in contemporary landscapes is Terry Evans, who started out as a drawing and painting major at the University of Kansas, and who, when graduating in 1968, was already working as a documentary photographer. Her early interest was poverty on the Great Plains and the natural and cultural systems of these vast open spaces have continued to dominate her interest. In 1978 she began photographing virgin prairie ecosystems, holding the camera at waist level to produce a kind of micro-aerial survey of the tiny but complex biotic ensembles, which could include up to 200 species even within such a tight frame (illus. 86). Wondering if the same kinds of patterns she was seeing up close would be apparent from 500 or 1,000 feet above the ground, she hired a plane to take true air photos. These revealed a prairie filled with natural and anthropogenic patterns. Her portfolio includes colour images of relatively undisturbed portions of prairie that contrast the views from the air and the ground. Gradually, she has extended her geographic range to include other agricultural and human landscapes. Commenting on her work, Evans claims not to be as interested in the beauty of abstract patterns as William Garnett, but captivated by the interrelations that occur at the boundaries between the abstract and the specific. Art history has had quite specific influence on her aesthetic: she draws on the spatial relationships in classical Chinese scroll paintings of landscapes, Persian miniatures and that moment in late medieval painting just prior to the invention of Renaissance linear perspective seen in the flattened illusions of space in altarpieces and illuminated manuscripts. Albrecht Dürer's 'gothic' patterns also fascinate

her; as with the other influences, they emphasize the relationship of individual parts to the whole.

Among Evans's more notable bodies of work are *Disarming the Prairie* and *Revealing Chicago: An Aerial Portrait*. The former examines the old World War II Joliet Arsenal 60 miles outside Chicago, now a 19,000-acre eco-reserve known as the Midewin National Tallgrass Prairie. Photographing from low altitudes and on foot, she assembled a series of juxtapositions between the military-industrial complex and the nature reserve that illustrate not just the contours of topography, but folds and overlaps in changing land use (see illus. 85). Like Hansen, MacLean and the Macdonalds, Evans balances the distanced view of aerial work with a commitment to environmental activism, and she works with nonprofit organizations seeking to preserve virgin prairie.

Working over Chicago, a city that Evans refers to as 'the urban prairie', the artist for the first time included people as part of the land-scape, not simply markers on the land. Flying in airplanes, helicopters and balloons at various altitudes and with different lenses, she built up a layered three-dimensional view of the city as pattern-in-process. Inmates in a prison yard form a regimented geometry, as do players on the volleyball courts arrayed on the sandy shores of Lake Michigan (illus. 87). Solo bicyclists pedal along a boulevard, seeming to pull the picture apart, while in another photograph crowds in a park make every pathway visible and animated. As in any low-altitude aerial view including people, issues of privacy arise, and Evans has stayed just high enough to register the impression of individual faces without our being able to identify them. In her most recent work, she photographs at ground level inside the same steel mills that she pictured from the air, producing another triangulation of urban space.

Questions of privacy have been thrown into sharp relief by the spread of CCTV in city public spaces and the ubiquity of the Google Earth images we have already discussed. Urban artist David Deutsch, educated in Los Angeles but now living in New York, explores these concerns in his *Nightsun* series: black-and-white photos taken from helicopters at night that parody police search tactics. Indeed, he

87 'Volleyball, North Avenue Beach', from *Revealing Chicago* by Terry Evans, 24 June 2003.

uses a powerful police searchlight to illuminate the ground, in this case revealing the random detritus of urban backyards, suburban front lawns, parking garages and the blank sides of anonymous buildings. The circular glare of the light, beyond which all detail is lost to darkness, imitates the vignette framed by a lens, reinforcing the reference to surveillance (see illus. 92). While his daylight work over residential areas is shot in colour and tends to feature neatly mown lawns and clean swimming pools, in the night work we are offered the image of a more chaotic and pathological city, as individuals whom we instantly take for criminals cross the image. What is actually revealed is a quotidian untidiness: old cars sinking into dead turf, jumbled plastic furniture, garbage cans askew. Deutsch's surveillance is not directed at individual acts, but at urban society in general.

The horizontal sprawl of the American city, the openness of its grid and the low density of its built areas and open spaces render it

88 Ed Ruscha, *Good Tires*, 6610 Laurel Canyon, North Hollywood, 1967, from *Thirty-Four Parking Lots*.

89 Ed Ruscha, *Pershing Square Underground Lot*, 5th and Hill, 1967, from *Thirty-Four Parking Lots*.

90 Ed Ruscha, *Dodgers Stadium*, 1000 Elysian Park Avenue, 1967, from *Thirty-Four Parking Lots*.

91 Ed Ruscha, *State Board of Equalization*, 14601 Sherman Way, Van Nuys, 1967, from *Thirty-Four Parking Lots*.

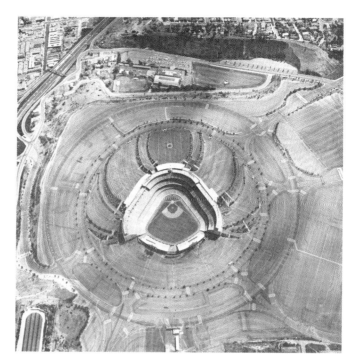

more interesting for aerial photography than the dense urban land-
scapes of the Old World that yield more fully to ground-level photography.
A seminal work over Los Angeles was made by the artist Ed Ruscha, who
hired a photographer in 1967 to fly in a helicopter over downtown parking
lots on a Sunday, when they were empty, and take vertical portraits of
them. Ruscha then compiled them into a typology, *Thirty-Four Parking
Lots*, which became a foundational publication in the New Topographics,
a countermovement to the Ansel Adams school of landscape photography
(illus. 88–91). The movement was defined by its factual presentation of
land use and owed no small debt to William Garnett's Lakewood photos.

92 David Deutsch, *Untitled*, resin-coated
silver gelatin black-and-white print, 2000.

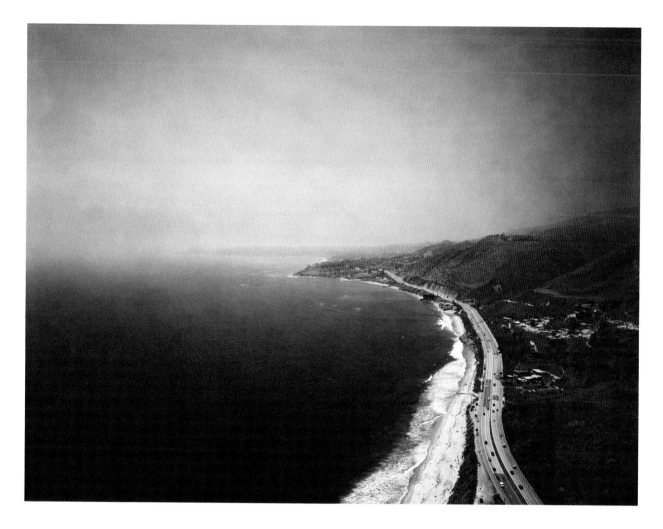

93 Florian Maier-Aichen, *Untitled*, 2005.

Two European urban photographers, Olivo Barbieri, born in 1954 and living in Milan, and the German Florian Maier-Aichen, born in 1973, who divides his time between Cologne and Los Angeles, have found inspiration over cities worldwide. In recent years Barbieri has abandoned the landscape convention of keeping the entire depth of field in focus, and by tilting and shifting his lens in relationship to the back plane of the camera he deliberately produces a shallow focal plane. Thus only one slice of the picture is in focus, while the rest blurs into indistinction. As a result, aerial photographs in his *Site Specific* series – enormous prints of cities including Rome, Amman and Shanghai as well as the western

US cities of Las Vegas and Los Angeles – are read as hyperrealistic toy models. The Las Vegas photographs of hotel-casinos are especially ambiguous, as the buildings are themselves simulacra of iconic, Old-World urban landscapes: Venice, New York and Paris. The combination of what we read as aerial veracity together with Barbieri's highly selective focus transfixes viewers as they attempt to interpret the image.

Maier-Aichen adopts the opposite strategy, creating photos of immense depth and width. Shooting from a variety of altitudes and often with infrared film, he stitches together several negatives to create an image that occupies not only a part of the colour spectrum to which the human eye does not normally have access, but also assembles a view that a human could not see without moving the vantage point from place to place, a technique used to great affect by Maier-Aichen's compatriot Andreas Gursky. But while Gursky and his colleague Thomas Struth (both students of photographic typologists Bernd and Hilda Becher) tend to follow the movement's aesthetic of taxonomic order, Maier-Aichen abandons any catalogue of the typical or consistent stylistic vantage point in favour of constant experimentation. He acts more like Schulthess in manipulating his prints, digitally inscribing them and stitching together infrared images, all in an attempt to create views that are both aerially and panoramically spacious (illus. 93).

Among the contemporary artists who have achieved the broadest reach with the camera in flight is the San Francisco photographer Michael Light, who uses images taken from a variety of aerial platforms: aeroplanes, helicopters and even spacecraft. As is the case with a number of photographers working in the air, flight is almost an emblematic part of Light's family history. His great-uncle Richard Light learned to fly in World War I, and in 1934–5 became the first aviator to fly around the world in a seaplane. In 1937–8 he flew with his wife, Mary Upjohn, through the length of South America to Rio de Janeiro, then shipped their six-seat monoplane to Cape Town where they resumed their journey, this time flying 32,000 km (20,000 miles) north through the continent of Africa. Upjohn spent much of the flight hanging out the window with a bulky 5×7 Fairchild aerial camera, making the first photo transect of the continent. Her photographs, arranged chronologically and by region

94 Michael Light, from *Some Dry Space*, 2004.

6 DBCR-PBM(U)-178-403/25JULY46/20"/OBL/12,000'/BIKINI/

96 Michael Light, *Over Los Angeles*, 2004.

95 Michael Light, reprinted photograph from *100 Suns* (2003) of the 1946 'Baker' atomic bomb test on Bikini atoll.

in their book, *Focus on Africa*, remain a baseline document for the geography and land use practices of Africa in the fourth decade of the last century. Close-ups of farms, for example, reveal the shift from the indigenous and organic shapes of fields melded to the contour lines of dambos and drainage channels to the colonial grid and wildlife enclosures, with their straight-and-furrow ploughing and angular borders, and then back again to contour ploughing as the European settlers responded to the consequent erosion, adopting American practices learned from the Dust Bowl. Richard Light's writing is winsome, but it poses the question

97 David Maisel, *1364–4171* from *Oblivion*, 2006.

central to any aerial views considered as documentation: 'Can a person visit a country yet never set foot upon it? Does an airplane journey across a territory entitle the traveler to claim that "he has been there"?'

This heritage in aerial photography as exploration played no small part in the first project for which Michael Light gained international acclaim, *Full Moon*. Working in the Nevada desert in 1994, he noticed its similarity to the lunar landscapes he remembered from Apollo space flight records, which in turn led him to NASA's Johnson Space Center, where he was able to examine many of the 17,000 negatives taken by Apollo astronauts during their lunar missions. He edited the collection down to 130 images, vastly expanded the scale of the prints and arranged them as a walk-through exhibition that documented the greatest aerial photographic exploration ever undertaken. The show was mounted in cities across the world and accompanied by a large-format book. It stimulated Light to take flying lessons, purchase a plane and start photographing the western American deserts and its cities from the air. *Some Dry Spaces* traces the arroyo patterns and related vegetation lines, follows the flow of water from the eastern Sierras into Los Angeles, dips beneath the rim of one of the largest manmade holes in the planet (the Bingham copper pit in Utah) and probes the vast military preserves of Nevada (illus. 94). *100 Suns* re-masters photographs of 1950s atmospheric nuclear tests in Arizona, the Pacific and Australia, many of the images taken from aircraft in order to capture the full majesty and awe of the fireballs and mushroom clouds (illus. 95). The geography of Light's own photographic work is often ambiguous: the scale of the black-and-white oblique views, which are commonly rendered as prints measuring 36×44 inches or larger, is indeterminable at first. It can be difficult to know if the ground beneath the camera is rising or falling, and the time of day or season. Such indecipherability has the effect of capturing the viewer's attention, and disturbing our taken-for-granted ways of picturing the world from above.

Light's more recent work, over Los Angeles, often taking pictures with the camera pointed almost directly into the sun, capture not only the conventional forms of the city grid and its tangles of freeways and channelized arroyos, but also the evenly dispersed quality of atmospheric

133

Grave-site	
Izbica:	Kosovo: 99/06/06/
SPOT Scene:	4•082-264•99/06/06/•09:32:30•1•M
Extents:	100 pixels
Top Left:	Latitude: N42:43:45.76 Longitude: E20:39:37.96
Bottom Right :	Latitude: N42:43:41.98 Longitude: E20:39:41.48
Coverage:	100 meters x 100 meters
Scale:	1 pixel = 10 meters

light that attracted moviemakers early in the twentieth century. The result is a dramatic blanching of the urban landscape, ironically making the city seem to fit more comfortably into its semi-desert natural setting (see illus. 96). Los Angeles's opalescent light, through which shadows are diminished on film, also has been used to good effect over the city by David Maisel, whose black-and-white images taken from a helicopter flying at 10,000 feet (3,048 metres) are printed in negative. Not only does this switch make the normally white sky ominously black, it also renders the shadows of freeways a transparent white, and buildings appear hollowed out as if by bombs. The title of Maisel's series, *Oblivion*, is appropriately apocalyptic for a city often pictured in movies devastated by natural and manmade disasters. Both David Maisel and Michael Light make explicit use of the 'sunshine and noir' conventions associated with Los Angeles to create images that decouple us from the ground below. These are not mapping gestures, and they consciously refuse to provide orientation, forcing us to approach the urban view on new, if uncannily familiar, terms (see illus. 97).

98 Laura Kurgan, *French SPOT satellite image over Kosovo, Bosnia*, 1999.

99 Laura Kurgan, *Yellow* from *Monochrome Landscape*, 2004.

134

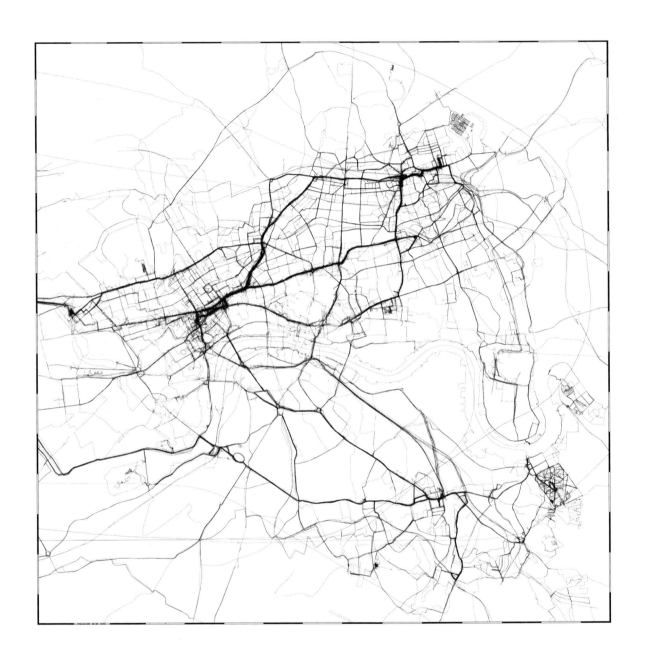

Remote Sensed Images and Art

Contemporary artists have eagerly exploited the new remote sensing technologies that have complemented conventional aerial photography in shaping the aerial image of the earth. They have been fascinated by the capacities of satellite images and GIS to reveal aspects of the earth's surface and the human occupation of it that were hitherto hidden. They have also been strongly critical of the potential for surveillance inherent in these technologies, and often actualized in their use by the state. Among the earliest and most creative artists is the American Laura Kurgan, who made use in the 1990s of French SPOT satellite images taken over Bosnia to reveal through the evidence of disturbed ground the location of mass graves of victims slaughtered during the civil war between ethnic groups (see illus. 98). She later reproduced on a gallery floor large-scale satellite images of Manhattan taken during the aftermath of the 9/11 attacks. Viewers were able to walk over the image and trace the plume of smoke from the ruined buildings. In a lighter vein, she has recently produced a series of images titled *Monochrome Landscapes* by asking Space Imaging Inc., a commercial company that stores image data at a resolution of 1 metre per pixel from its Ikonos satellite, 'for pictures of places characterized by one of four basic colors: white, blue, yellow and green'. The result is a set of startlingly beautiful rectangles of ice cap, ocean, desert and rainforest landscapes, each assigned a unique location, time and heat value. They are 'photographs: information, event, surface, pattern, chance encounter, memory, field of color' (see illus. 99).

Other artists have used the capacities offered by digital photography and computer programs such as Adobe Photoshop to manipulate aerial images in imaginative and challenging ways. The Dutch artists Florian Boer and Christine Dijkstra, for example, have used this technology to invert the spaces of city and country seen on a vertical air photo, filling the former space with forest and the latter with roads and houses. Jeremy Wood has overwritten aerial photos of London along the line of the Prime Meridian with fine tracings that follow boundaries but on close inspection also inscribe Herman Melville's famous lines across the landscape: 'It is not down in any map; true places never are.' These examples represent

100 London GPS map by Jeremy Wood, 2009.

137

a seemingly inexhaustible interest among contemporary artists in the creative possibilities offered by aerial imaging and mapping (illus. 100).

While the images created by the photographers Light, Maisel and Barbieri and artists such as Kurgan, Boer and Dijkstra and Wood adopt much of the same visual orientation as those prehistoric wall murals at Çatalhöyük – the streets and ground below seen in plan, the hills and distant mountains in elevation – their photographs stretch and place in question our capacity to register and interpret the earth's surface. Perhaps the impulse to picture the world from above was never simply to document and comprehend it from the elevated, godlike view provided by altitude, but rather is a creative act in all cases. Photography and powered flight have extended both these aspects of the view from above, and increasingly allow us to parse the condition of the world and its inhabitants in real time, all the time and everywhere. On our home computers the aerial view is becoming increasingly banal, but aerial artists are using the camera to create wholly new images of extraordinary reach and power, images that deepen our understanding of the world beyond its surface appearances, sometimes by re-complicating our view of it, but always making us consider the everyday ways in which we relate to it.

Select Bibliography

Adams, Ansel, and Nancy Newhall, *This is the American Earth* (San Francisco, CA, 1960)

Appleton, Jay, *The Experience of Landscape* (Chichester, 1996)

Apt, Jay, Michael Helfert and Justin Wilkenson, *Orbit: NASA Astronauts Photograph the Earth* (Washington, DC, 1996)

Arthus-Bertrand, Yann, *The Earth from the Air* (Paris, 1999)

Baker, Simon, 'San Francisco in Ruins: The 1906 Photographs of George R. Lawrence', *Landscape*, XXX/2 (1989), pp. 9–14

Beaumont, Newhall, *Airborne Camera: The World from the Air and Outer Space* (New York, 1969)

Berger, Alan, *Drosscape: Wasting Land in Urban America* (New York, 2006)

—, *Reclaiming the American West* (New York, 2002)

Blaut, James M., 'Natural Mapping', *Transactions of the Institute of British Geographers*, new series, XVI/1 (1991), pp. 55–74

Bourke-White, Margaret, *Portrait of Myself* (New York, 1963)

—, *Twenty Parachutes* (Tucson, AZ, 2002)

Breydenbach, Bernhard von, *Peregrinatio in Terram Sanctam* (Mainz, 1486)

Bridges, Marilyn, *Markings: Sacred Landscapes from the Air* (New York, 1986)

—, *The Sacred & Secular: A Decade of Aerial Photography* (New York, 1990), essay by Vicki Goldberg with interview by Anne H. Hoy

Brown, Theodore M., *Margaret Bourke-White: Photojournalist* (Ithaca, NY, 1972)

Bunnell, Peter C., *Emmet Gowin: Photographs 1966–1983* (Washington, DC, 1983)

Burkhard, Balthasar, *Photographer* (Zurich, 2004)

Callahan, Sean, ed., *Margaret Bourke-White: Photographer* (Boston, MA, 1998)

—, *The Photographs of Margaret Bourke-White* (New York, 1972)

Campanella, Thomas J., *Cities from the Sky: An Aerial Portrait of America* (Princeton, NJ, 2001). More than 100 photographs taken between the 1920s and '60s by the Fairchild Aerial Survey Company are accompanied with a foreword by Witold Rybczynski.

Clark, Kenneth, and Carlo Pedretti, *The Drawings of Leonardo da Vinci in the Collection of Her Majesty the Queen at Windsor Castle*, 2nd edn (London, 1969), vols I–II

Corner, James, and Alex S. MacLean, *Taking Measure across the American Landscape* (New Haven, CT, 1996)

Cosgrove, Denis, *Apollo's Eye* (Baltimore, MD, 2001)

Dicum, Gregory, *Window Seat: Reading the Landscape from the Air* (San Francisco, 2004). An armchair guidebook to deciphering aerial views.

Diesel, Eugen, and Robert Petschow, *Das Land der Deutschen* (Leipzig, 1931)

Dreikausen, Margaret, *Aerial Perception: The Earth as Seen from Aircraft and Spacecraft and Its Influence on Contemporary Art* (Philadelphia, PA, 1985)

Dunaway, Finis, *Natural Visions: The Power of Images in American Environmental Reform* (Chicago, IL, 2005)

Evans, Terry, *Disarming the Prairie* (Baltimore, MD, 1998)

—, *The Inhabited Prairie* (Lawrence, KS, 1998)

—, *Prairie: Images of Ground and Sky* (Lawrence, KS, 1996)

—, *Revealing Chicago: An Aerial Portrait* (New York, 2006)

Fox, William L., *Aereality: Essays on the World from Above* (Berkeley, CA, 2009)

Garcia Espuche, Albert, *Cities: From the Balloon to the Satellite* (Madrid, 1994)

Garnett, William, with an introduction by Ansel Adams, *The Extraordinary Landscape: Aerial Photographs of America* (Boston, MA, 1982)

—, *William Garnett: Aerial Photographs*, with an introduction by Martha A. Sandweiss (Berkeley, CA, 1994). While the former title by Garnett is a colour book of predominantly nature photographs from the air, this second book is a highly aestheticized presentation of black-and-white art images based on strong ground patterns perceptible primarily, or even exclusively, from the air.

Gerster, Georg, *Brot und Salz: Flugbilder* (Basel, 1985)

—, *Flights of Discovery* (New York, 1978)

—, *The Past from Above* (Oxford, 2005)

Gohlke, Frank, *Landscapes from the Middle of the World* (San Francisco, CA, 1988)

Gosling, Nigel, *Nadar* (London, 1976)

Gowin, Emmet, *Changing the Earth* (New Haven, CT, 2002). This exhibition catalogue, published in conjunction with the Corcoran Gallery of Art, includes essays by exhibition curator Jock Reynolds and nature writer Terry Tempest Williams ('The Earth Stares Back')

—, *Emmet Gowin: Photographs* (Philadelphia, PA, 1990), with an essay by Martha Chahroudi

Harley, J. B., and David Woodward, eds, *The History of Cartography* (Chicago, IL, 1987–) The first volume of this magisterial and definitive series was published in 1987, and contains a seminal essay on early mapping images, including the wall mural at Çatalhöyük, by Catherine Delano Smith, 'Cartography in the Prehistoric Period in the Old World: Europe, the Middle East, and North Africa'. The same volume has P.D.A. Harvey's discussion of early bird's-eye city images in 'Local and Regional Cartography in Medieval Europe'

Hanson, David T., *Waste Land: Meditations on a Ravaged Landscape* (New York, 1997)

Hauser, Kitty, *Shadow Sites: Photography, Archaeology, and the British Landscape 1927–1951* (Oxford, 2007)

Hawkes, Jason, *Aerial: The Art of Photography from the Sky* (Hove, 2004). Images and text by a leading UK commercial photographer

Hayden, Dolores, *A Field Guide to Sprawl* (New York, 2004)

Hodder, Ian, ed., *On the Surface: Çatalhöyük 1993–95* (Cambridge, 1996)

—, *The Leopard's Tale: Revealing the Mysteries of Çatalhöyük* (London, 2006)

Johnson, Lt. George R., *Peru from the Air* (New York, 1930)

Kost, Julieanne, *Window Seat: The Art of Digital Photography & Creative Thinking* (Sebastopol, CA, 2006)

Lartigue, Jacques-Henri, *Boyhood Photos of J.-H. Lartigue: The Family Album of a Gilded Age* (Lausanne, 1966)

Le Corbusier, *Aircraft: The New Vision* (London, 1935)

Light, Richard Upjohn, *Focus on Africa* (New York, 1944), photographs by Mary Light

MacDonald, Angus, and Patricia MacDonald, *Above Edinburgh and South-east Scotland* (Edinburgh, 1989)

MacLean, Alex, with text by Bill McKibben, *Designs on the Land: Exploring America from the Air*, with an introduction by Corner and essays by MacLean, Gilles A. Tiberghein and Jean-Marc Besse (London, 2003)

—, *Look at the Land: Aerial Reflections on America* (New York, 1993)

Maisel, David, *Exposed Terrain* (New York, 1990). Early work by Maisel after he photographed the aftermath of the Mt Saint Helens explosive eruption.

—, *The Lake Project* (Tucson, AZ, 2004)

Marinoni, Augusto, ed., with a foreword by Carlo Pedretti, *Leonardo da Vinci: The Codex on the Flight of Birds in the Royal Library at Turin* (New York, 1982)

Martin, Rupert, ed., *The View from Above: 125 Years of Aerial Photography* (London, 1983)

Monmonier, Mark, 'Aerial Photography at the Agricultural Adjustment Administration: Acreage Controls, Conservation Benefits, and Overhead Surveillance in the 1930s', *Photogrammetric Engineering and Remote Sensing*, LXVIII/11 (December 2002), pp. 1257–61

Morse, Rebecca, *Florian Maier-Aichen* (Los Angeles, CA, 2007)

Nuti, Lucia, 'The Perspective Plan in the Sixteenth Century: The Invention of a Representational Language', *Art Bulletin*, LXXVI/1 (March 1994), pp. 105–28

Paschal, Huston, and Linda Johnson Dougherty, *Defying Gravity: Contemporary Art and Flight* (Raleigh, NC, 2003). An exhibition catalogue with contributions by Robert Wohl and others.

Price, Alfred, *Targeting the Reich: Allied Photographic Reconnaissance over Europe, 1939–1945* (London, 2003)

Pyne, Stephen J., 'SPACE: The Third Great Age of Discovery' in *SPACE: Discovery and Exploration* (New York, 1993)

Reps, John, *Bird's Eye Views: Historic Lithographs of North American Cities* (New York, 1998)

Schaaf, Larry J., *The Photographic Art of William Henry Fox Talbot* (Princeton, NJ, 2000)

Schulthess, Emil, *Antarctica: Swiss Panorama* (New York, 1983), text by Emil Egli, trans. A. J. Lloyd

Sekula, Allan, 'The Instrumental Image: Steichen at War', *ArtForum*, XIV (December 1975), pp. 26–35

Sichel, Kim, *To Fly: Contemporary Aerial Photography* (Boston, 2007)

Siegel, Beatrice, *An Eye on the World* (New York, 1980)

Solso, Robert, *Cognition and the Visual Arts* (Cambridge, MA, 1994)

Stanley, Col. Roy M., *World War II Photo Intelligence* (New York, 1981)

St Joseph, J.K.S., ed., *The Uses of Air Photography: Nature and Man in a New Perspective* (New York, 1966)

Waldheim, Charles, 'Aerial Representation and the Recovery of Landscape', *Recovering Landscape: Essays in Contemporary Landscape Architecture*, ed. James Corner (New York, 1999)

Weems, Jason, 'Aerial Views and Farm Security Administration Photography', *History of Photography*, XXVIII/3 (Autumn 2004), pp. 267–82

Whimster, Rowan, *The Emerging Past: Air Photography and the Buried Landscape* (London, 1989)

Wohl, Robert, *A Passion for Wings: Aviation and the Western Imagination* (New Haven, CT, 1994

—, *The Spectacle of Flight: Aviation and the Western Imagination, 1920–1950* (New Haven, CT, 2005)

Weiner, Tim, 'Pentagon Envisioning a Costly Internet for War', *New York Times* (12 November 2004)

Websites

www.centennialofflight.gov (as of August 2007)

landsat.usgs.gov/

www.yannarthusbertrand.com

Acknowledgements

This book was the brainchild of the late Denis Cosgrove and Reaktion publisher Michael Leaman. Although Denis was able to finish our collaboration over the text, his passing in 2008 was an incalculable loss to our ability to select plates. Everyone at Reaktion has been incredibly supportive during the slow completion of the project, including Michael, Robert Williams, Harry Gilonis, Ian Blenkinsop and picture researcher Suzannah Jayes. In addition, the UCLA Department of Geography under the chairmanship of David Rigby made it possible for Rick Miller to do the initial picture research from Los Angeles.

Over the years I have had the pleasure of working and flying with a number of photographers whose work deeply informed this work. Among them are Terry Evans, Michael Light, and David Maisel. The Getty Research Institute hosted Denis, Michael Light, Lucia Nuti and myself in a discussion of the God's-Eye View in 2007, and my thanks to Charles Salas and Tom Crow for making possible the symposium while they were on staff there. Other people and their organizations lending their resources were Matthew Coolidge and the Center for Land Use Interpretation, and Mike Smith at the National Museum of Australia. And, as ever, I would like to thank my colleagues at the Nevada Museum of Art for their thoughtful comments on all matters aesthetic, in particular Ann Wolfe and Colin Robertson.

Index

Numbers in *italic* refer to illustrations

100 Suns 130, 131, 133

Aberdeen (South Dakota) 21
Aborigines 11
Above Edinburgh and South-East Scotland 121, 140
Adams, Ansel 65, 66, 102, 105, 116, 126, 139
Adobe Photoshop 94, 137
Aerial Photographic Research (US Army) 42
Aerofilms 46, 69
Aerographica 120
Africa 22, 27, 44, 51, 55, 66, 86, 90, 106, 120, 128, 131, 139, 140
Agriculture Adjustment Administration (AAA) 50
airmen's vision 52, 59
Airports Council International 92
Alaska 88
Altdorfer, Albrecht 17, 18
 The Battle of Alexandria and Darius at Issus 18
Amundsen-Scott Station *106*
Anders, Bill 83
Anderson, O. A. 53
Angkor Wat *116*
Annonay 23, *23*
Antananarivo, Madagascar *91*
Antarctic, Antarctica 45, 67, 86, 90, 106, 140
Antarctic Peninsula *76*
Anzio 55
Aperture Foundation 116
Apollo lunar program 81, 83-86, 133, 139
Arabian Peninsula 86
Arago, Dominique François Jean 24
archaeology, archaeologists 14, 29, 36-38, 41, 43, 45, 79, 102, 109, 139
Archaeologica 36
Archibald, E. D. 27
Argentina 27
Army Air Corps (US) *54,* 55
Arno 16
atmospheric perspective 18
Auschwitz *58*
Australia 11, 14, 21, *22,* 45, 90, 133

Baghdad 38
Barbari, Jacopo de' 19
Barbieri, Olivo 127, 128, 138

Batut, Arthur 28, *28,* 29
Bates, Marston 68
Beazeley, Colonel G. A. 37
Becher, Bernd and Hilda 128
Bel Geddes, Norman 48
Bingham Copper Pit (Utah) 133
bird's-eye perspective, view 8, 17, 21, 22, *22,* 28, 50
Black, James Wallace (J. W.) 7, *8,* 27
Blackbird 72, 73
'Blue Marble', the *85,* 86
Boes, Florian 137
Boileau family *22*
Bonvillain, L. P. *33*
Bosnia 134, 137
Boston 7, 27, *71,* 88, 139, 140
Bourke-White, Margaret 49, 57, *58,* 65–6, 102, 139
 New Deal, Montana: Fort Peck Dam 49
Bragalglia, Anto Giulio 32
Braque, Georges 32, 100
Braun and Hogenberg 19, *20,* 21
Breydenbach, Bernhard von 19, 139
Bridges, Marilyn 108–9, *110,* 139
British Air Intelligence 55
British Ordnance Survey 41
British East Africa 51
Brower, David 66
Brownie (camera) 34, 44, 90
Bruegel, Pieter (the Elder) 17
Brueghel, Pieter (the Younger) 17
Brunhes, Jean 101
Brunelleschi, Filippo 14
Byrd, Robert 87

Cameron, Robert 90, 92
camouflage 26, 35–6, 71–2
Campanella, Thomas 51, 139
Canada 60
Canadian Arctic 67
Canadian Department of Agriculture 79
Cape Town 22
Cartier-Bresson, Henri 102, 105, 107
Casa de Indias 23
Castell, (Count) Wulf Diether zu 45
Castle Dore *60*
Çatalhöyük *2, 13,* 14, 16, 43, 138–40
Central Intelligence Agency (CIA) 73

142